MONDAY HEARTS

for

MADALENE

PAGE HODEL

STEWART, TABORI & CHANG
NEW YORK

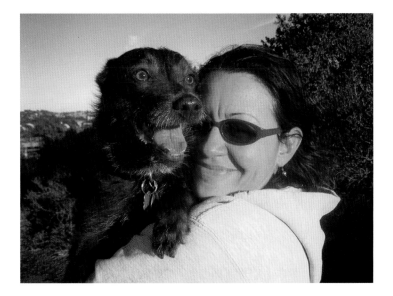

MADALENE LOUISE RODRIGUEZ

January 11, 1960–June 20, 2006

This book is dedicated to
MADALENE
whose love has changed me forever

MARY, ELENA, VICKI, IVAN, AND THE ENTIRE RODRIGUEZ FAMILY
for their unimaginable loss

and my sister, ANN HODEL
whose heart exceeds the sum of all hearts

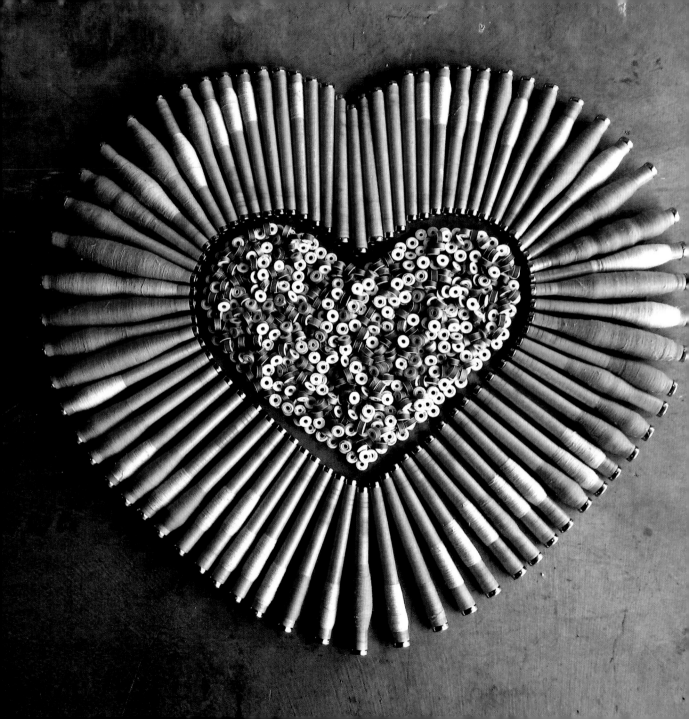

you hold in your hands a song of love

ᨊ It is my song of love to Madalene Louise Rodriguez ᨊ

IT IS THE STORY OF MY HEART *exploding* open at age 48 after finding the love I had searched for all my life, and my weekly *expression* of this glorious feeling. And it is the story of the unimaginable sorrow of losing Madalene soon after we fell in love, very suddenly to ovarian cancer, and the *journey* of my open heart as I navigated the jagged terrain of learning what to do with this uncontainable sea of *love* inside me for this incredible human being.

i began making these hearts for Madalene soon after we met. I worked late nights as a DJ in San Francisco, and Madalene worked days as a librarian in Berkeley. I lived across the street from Madalene, and every Sunday night after work, I would tippy toe across the street at 3 a.m. with a bowl of leaves or stones or flower petals—anything beautiful that I could find—to construct a heart for her on her doorstep. I wanted there to be a little heart waiting for her when she walked out the door to go to work every Monday morning. I wanted her to begin her week with a sweet reminder of my opening, rejoicing heart.

Each one was meant to be a simple, pretty, sweet "I love you"—an "I give you my heart."

I called them *Monday Hearts for Madalene*.

LOVE IS SUCH A PALPABLE THING, so inarguable and pure. From the moment Madalene and I met, I was dancing through my days so deeply alive. It was like there was a softness coating everything around me. Colors and flavors became so vivid and rich. Love is like a brilliant, delirious hurricane of happiness. It felt like the whole world was in love.

After seven dizzyingly romantic months together, Madalene woke up one day with a pain in her side, which after endless tests, was diagnosed as advanced stage ovarian cancer. What followed was her courageous determination to fight and, ultimately, her brave, graceful surrender to this savage disease. Madalene died four months later on June 20, 2006. She was 46 years old.

Not long before Madalene died, she expressed how much she had loved getting her Monday morning hearts. She shared with me that she would sometimes set the alarm clock for 3 a.m., so that she could sneak quietly to her living room window and watch me make them. I had no idea. That moment, I understood their gift, and I promised that I would continue to make them for the rest of my life, every Monday, to show her that I would never forget her. I have made them ever since. These hearts are like an endless river of love flowing from me.

About four months after Madalene's death, I sent a snapshot of one of the hearts to the cell phone of my very close friend Aarin Burch. She called me minutes later in tears. She said she could *feel* the love reverberating off her little phone screen. Strangely, I knew exactly what she meant.

Aarin's reaction gave me the chills, the kind you get when something touches your very core, your marrow. I understood that our love, so powerful and profound, had a deeper purpose. The feeling

was palpable, like a calling. It became clear to me at that moment that I was to put these hearts out into the world.

Although Madalene is no longer with me on this physical plane, in my heart her love is so alive and unchanged. In recognition of this unbelievably warm, kind, gentle soul, whose love changed my life so much, I wanted to find a way to share this beautiful feeling with those important to me.

As a weekly tribute to our beautiful Madalene, I began that next Monday to email my hearts to our friends and family with the invitation to forward them to their loved ones. My hope is that we blanket the world in this magnificent love.

"Why is the measure of love, loss?" Jeanette Winterson wrote in *Written on the Body*. I remember stopping cold as I read that line so many years ago, not knowing that later in my life I would come to understand the power of those words with every cell of my being. If you want to know how much you love someone, take her or him away forever. Your heart and soul and entire body will tell you. You will acquire an undeniable understanding of the size of that love.

Death demands your attention. It requires you to think your unthinkable. It insists that you go to your dark places, those places you have so carefully learned to avoid all your life. You are pushed far beyond what you ever imagined to be your limits. You must accept your unacceptable.

But it is in this darkness, this silence and emptiness, that the truth, for me, so graciously emerged. I came to fully comprehend the immensity, the unrivaled beauty, and the sheer glory of experiencing true deep LOVE. Meeting Madalene changed me forever.

I understood during that time, in the deepest parts of me, that love is the divine force on this planet. Love has always and will always link all beings throughout eternity. It is the highest act we do here. When we open our hearts to someone and truly receive their love, we are experiencing life's greatest miracle. We are awakened to the true magnificence of the whole world around us. It is a reminder that there is love in everything.

For me, making and sharing these hearts embodies the revelation of knowing and feeling this simple, profound truth. The intentional, outward expression of love is a remarkably powerful and vital act. Its effects are immeasurable and untrackable. Not only is the original declaration felt,

it sets in motion a reverberating, rippling effect, which reaches unintended destinations we may never know. Love begets love.

What has been incredible to me through the process of making these hearts is that they are so very much alive, as if they are voices asking to be heard. Writers, artists, and musicians have felt this throughout eternity. A voice coming from so deep within, which cannot be ignored. I like to think this voice is Madalene's speaking to me, revealing and sharing the beauty and grace in all things.

The materials for each heart seem to find each other. Each one has found me in its own way. It feels as though they jump up and throw themselves in my path, determined not to be over-looked. I can walk through a sea of objects, and the materials for my next heart practically dance before me. Colors and shapes vibrate electrically next to each other, creating unintended, yet somehow perfect, harmonies.

I am constantly awakened to the delirious beauty and the astounding delicate intricacy of the natural world around me. The rhythm of certain lines and textures drenches me in arresting, unbridled awe. It is as if each thing of beauty I see has a magnificent voice, and I am walking through a glorious gospel choir of visual harmony. It's like a sea of Jessye Normans.

I am also moved deeply by the conversation between the exquisite beauty and grace of nature and the deliberate and sometimes cumbersome voice of man-made materials. I am drawn to the juxtaposition of the order and the chaos. The ordinary is made extraordinary, with the breathtaking rhythms and patterns of repetition.

When I am in the presence of this beauty, I feel LOVE.
This book is a gift of that LOVE.

I once heard a children's song with a verse that went something like this: "Love is the only thing that the more you give away, the more you have." How profoundly wise and true are these words.

These hearts are my gift to Madalene, and now, our gift to the world.
To give and give and give…

There are no words.
The hearts tell the story.

page hodel

Sprinkled throughout this introduction, there are fifteen small photographs of the "early" hearts, the ones that I left on Madalene's doorstep while we were together. What follows is a collection of one hundred of my favorite hearts that I hope she has seen from Heaven.

If you would like to receive these hearts every Monday, or to learn more about the project, please visit www.mondayheartsformadalene.com.

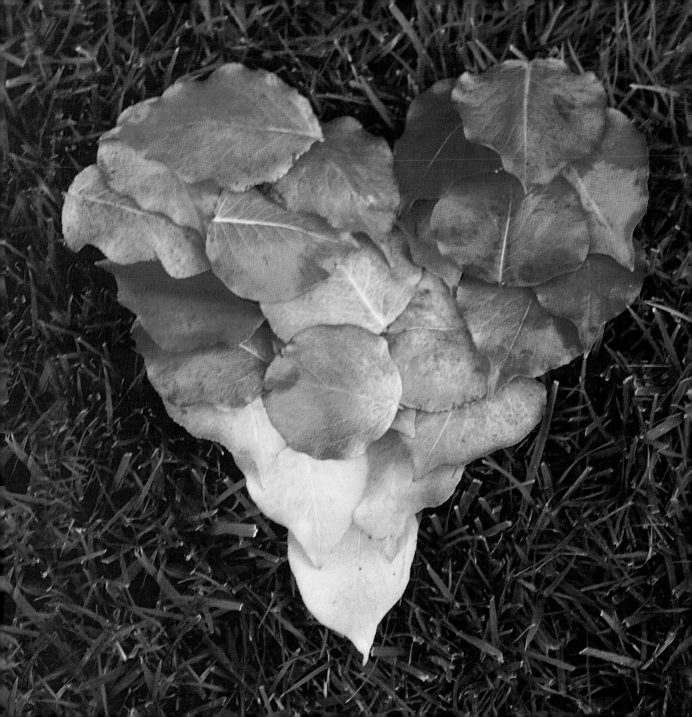

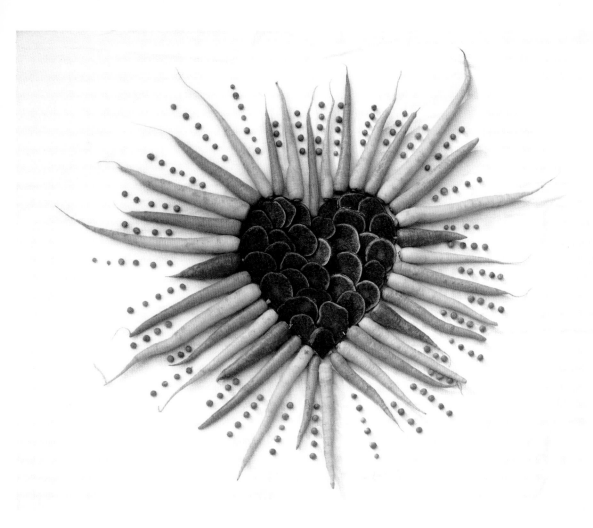

CARROT HEART

assorted varieties of carrots, peas, purple potatoes

❧

AUTUMN HEART

autumn leaves on grass

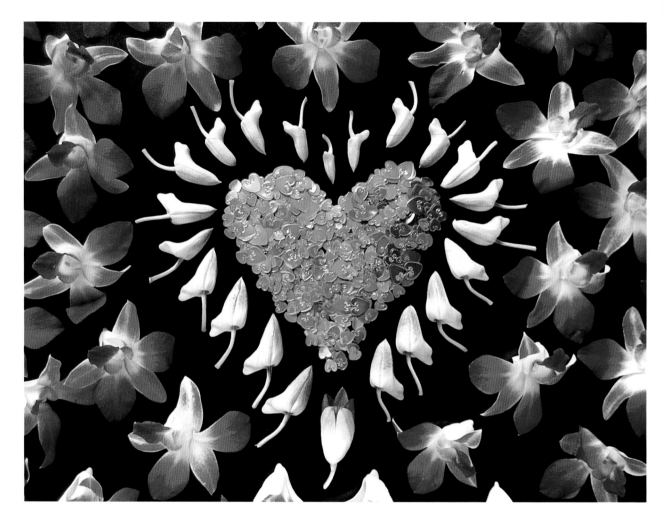

ORCHIDS FLOATING

orchids, heart-shaped confetti

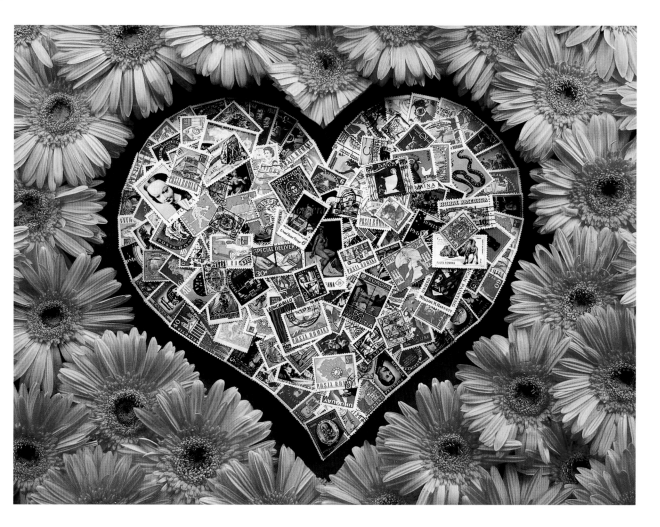

PINK STAMPS

Gerbera daisies, vintage Romanian stamps

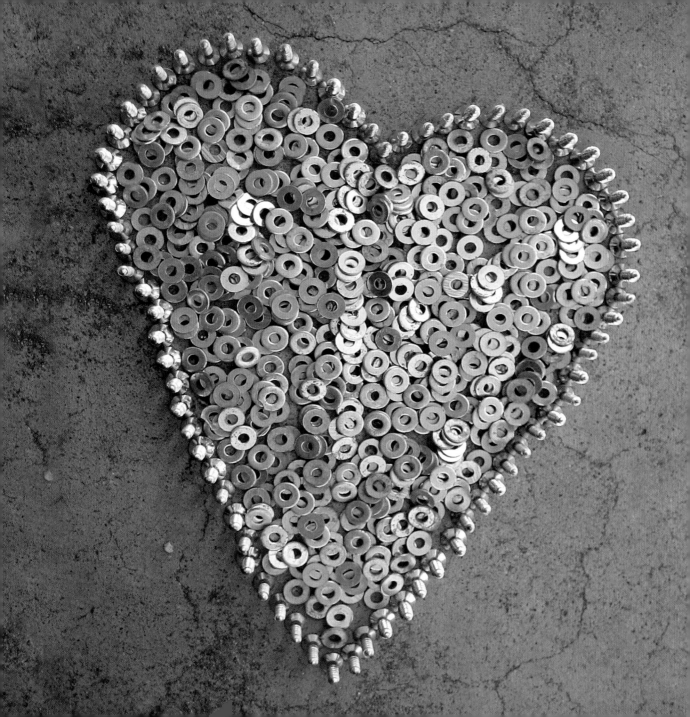

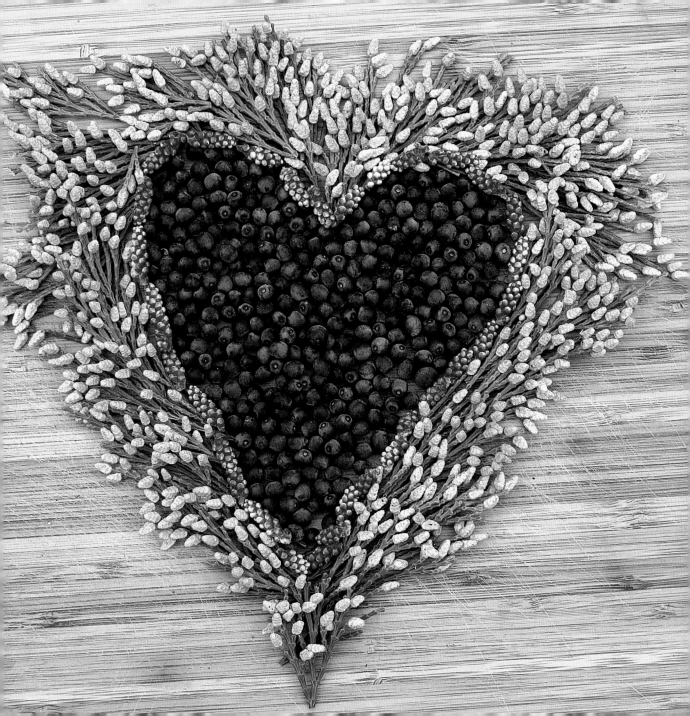

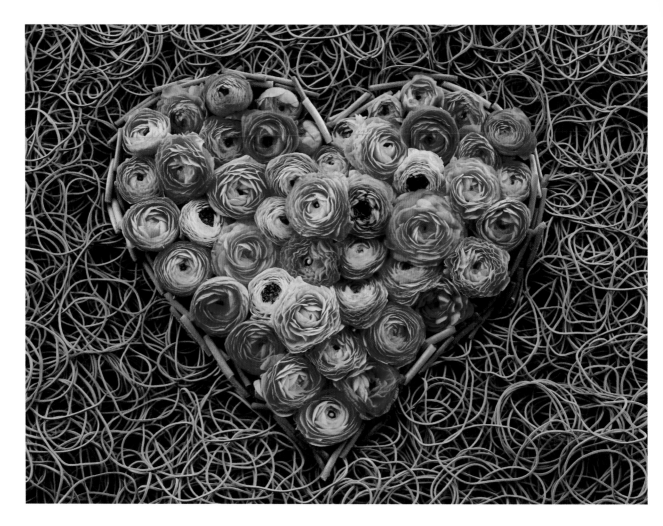

BLUE RUBBER BANDS
florist rubber bands, stems, Ranunculus flowers

❧

PREVIOUS PAGES
SCREWS AND WASHERS *screws and washers on concrete*
BLUES, REDS, YELLOWS *cedar buds, Callicarpa berries, and black privet berries on a cutting board*

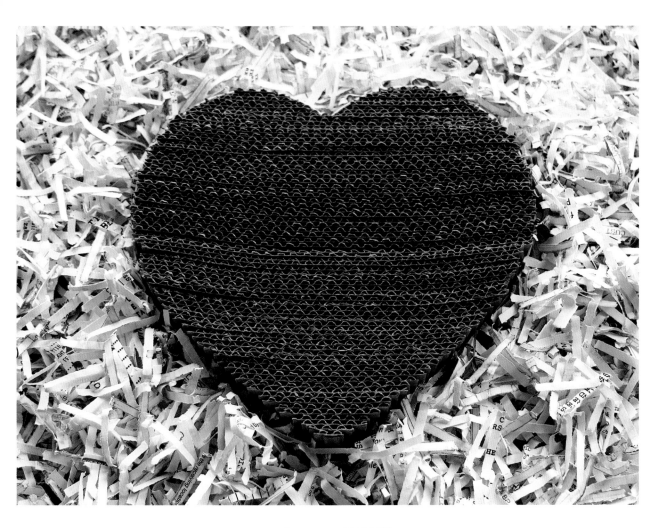

SUSTAINABLE HEART
shredded paper, cardboard

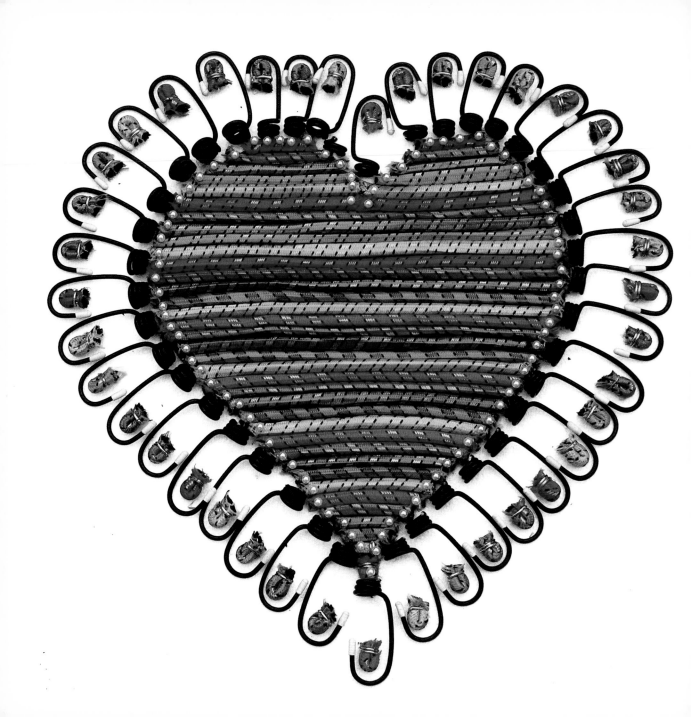

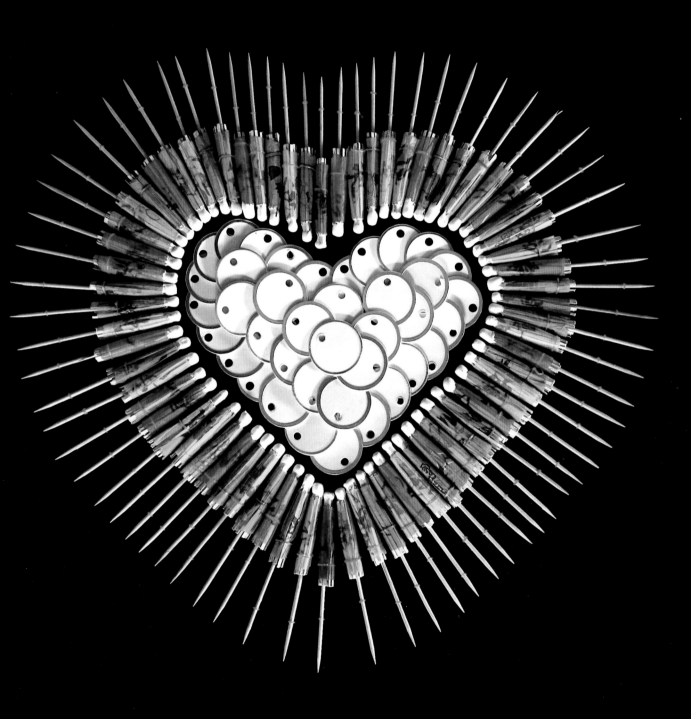

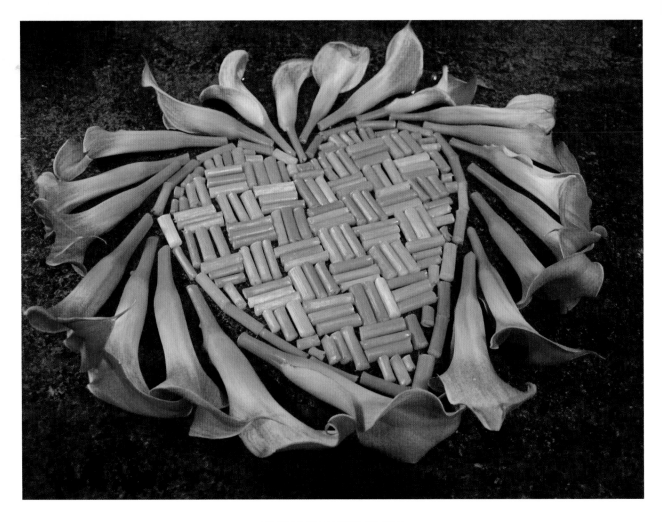

PINK LILIES WITH GREEN

calla lilies and their stems

❧

PREVIOUS PAGES
BUNGEE HEART *disassembled bungee cords* **PAPER UMBRELLAS** *cocktail umbrellas, key tags*

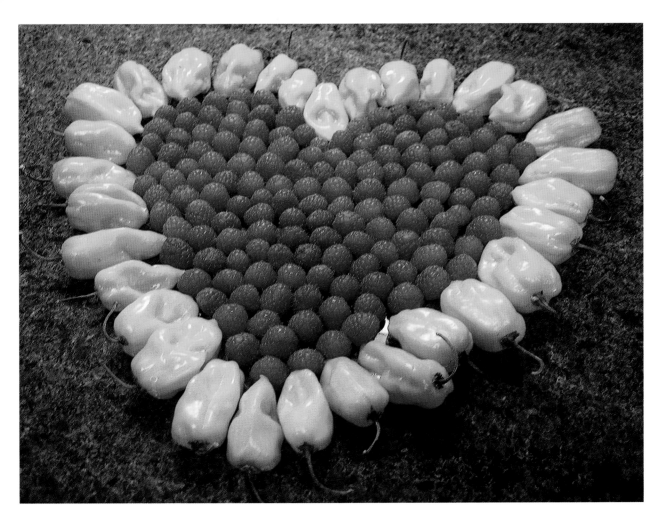

RASPBERRIES AND PEPPERS

habanero peppers and raspberries on granite

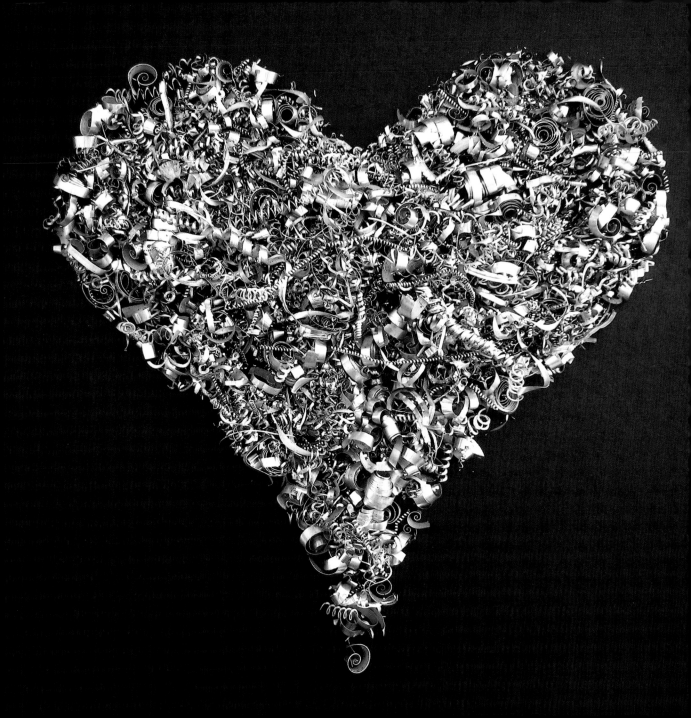

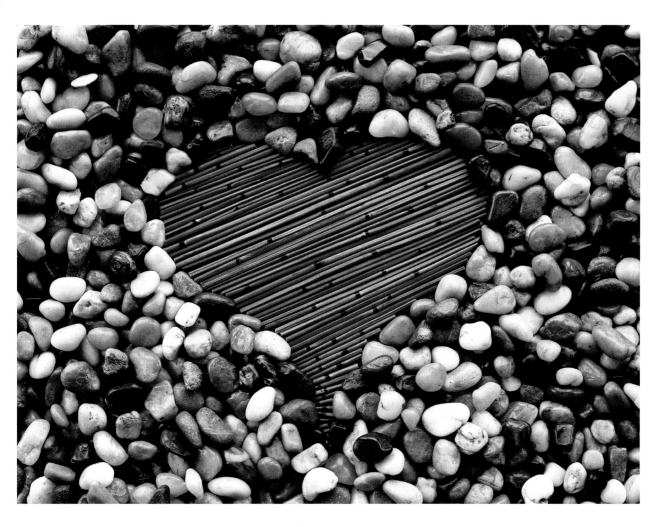

PEBBLES AND BAMBOO
multicolored pebbles, reeds

❧

DIVINE CHAOS
metal shavings

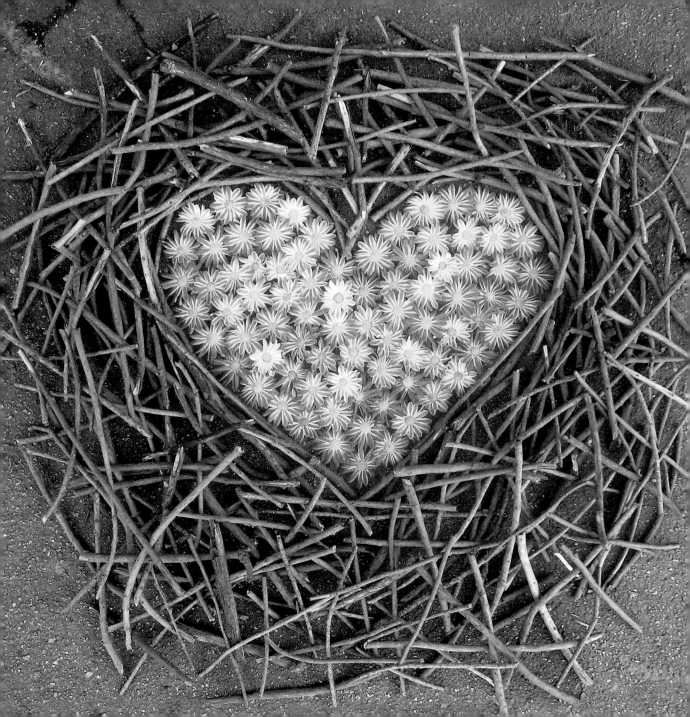

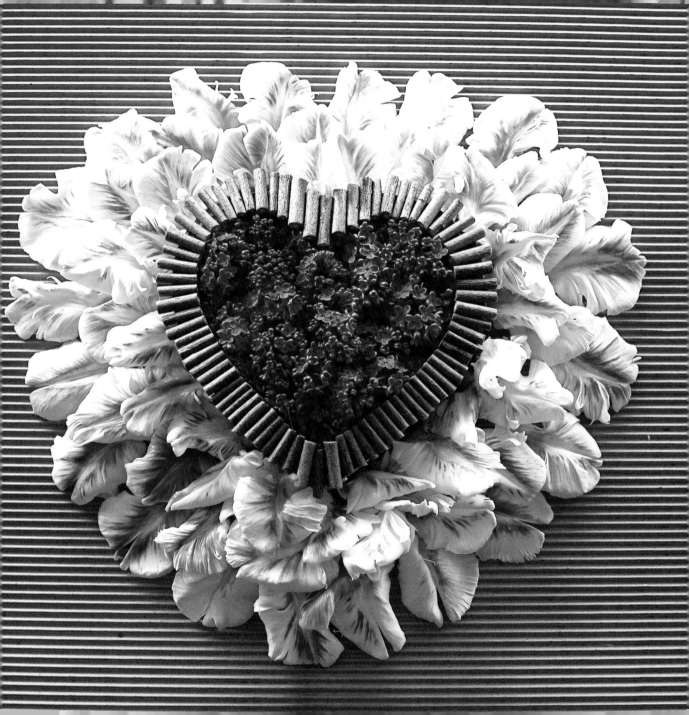

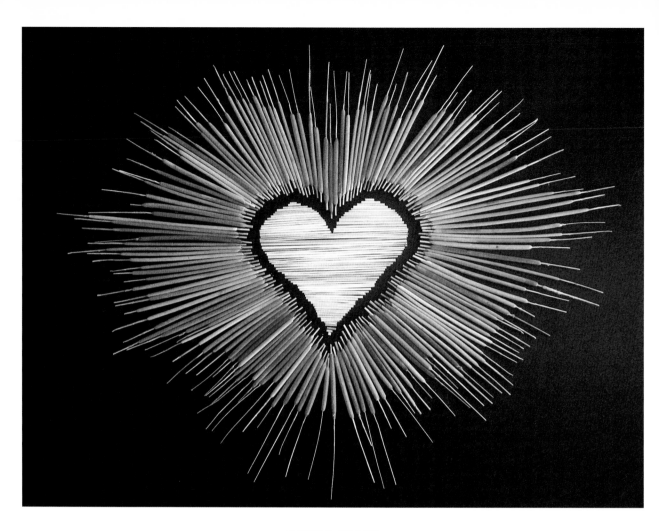

CATTAIL HEART
cattails, straw

❧

PREVIOUS PAGES
LOVE NEST *sticks, mini Tanacetum daisies* **PURPLE HEART** *parrot tulip petals, lilac stems and flowers*

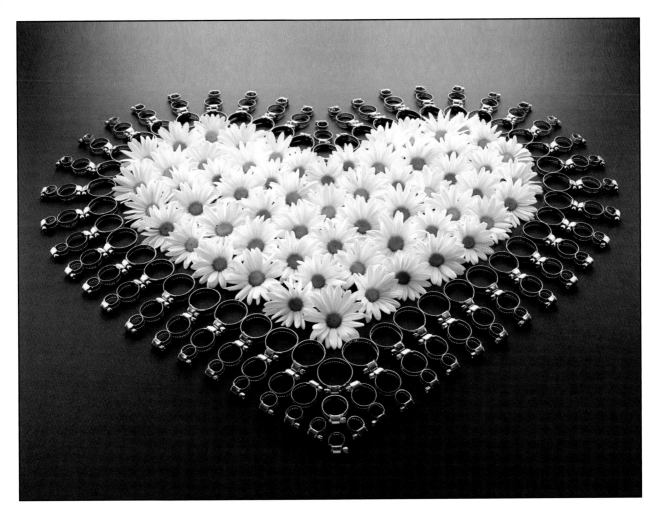

HOSE CLAMPS AND DAISIES

hose clamps, daisies

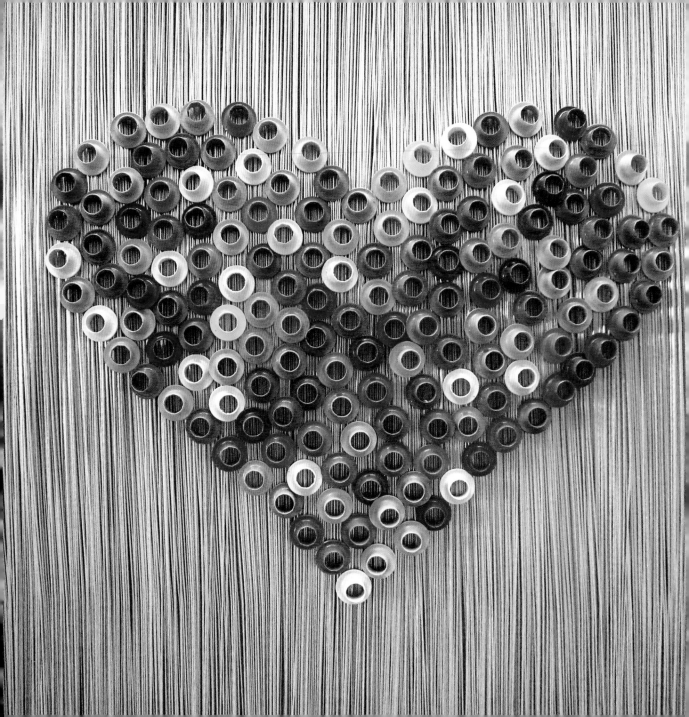

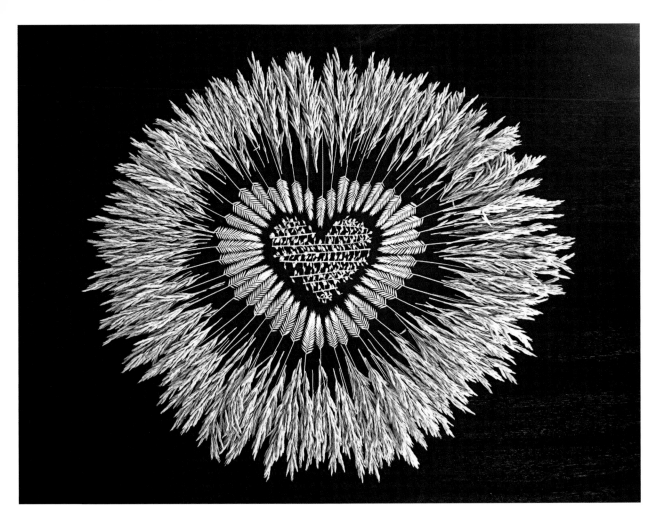

SUMMER GRASSES
dried wild grasses

❧

SILVER RAIN
multicolored rivets on silver wire

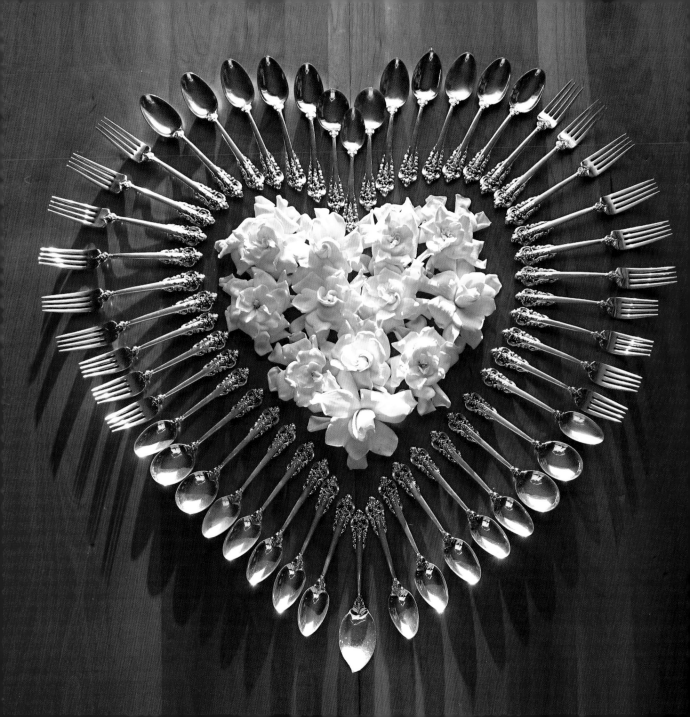

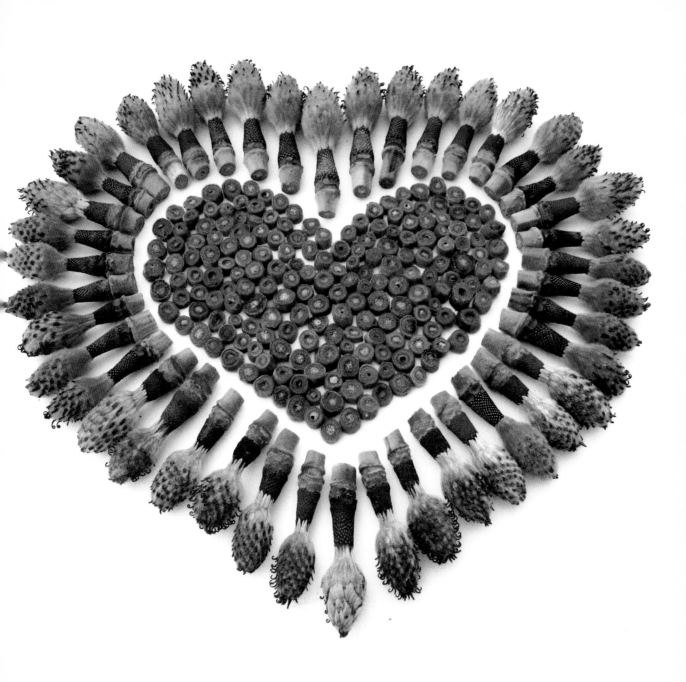

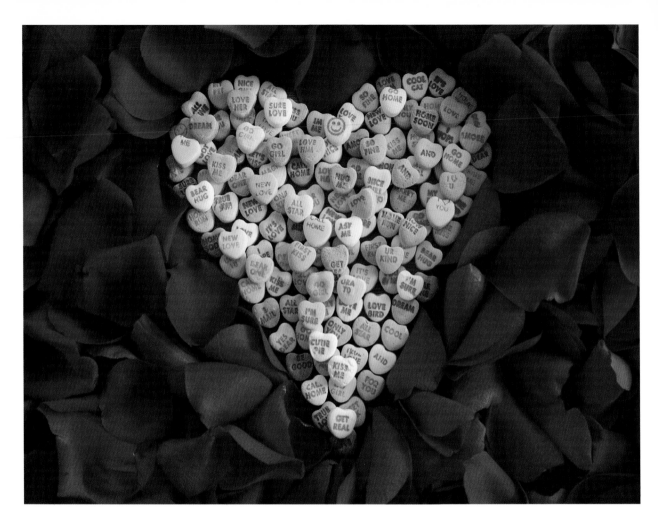

BE MINE

Valentine's Day heart candies on a bed of rose petals

❧

PREVIOUS PAGES

PAGE FAMILY SILVER *sterling silver spoons and forks, gardenias*

MAGNOLIA HEART *dried magnolia pods and their stems*

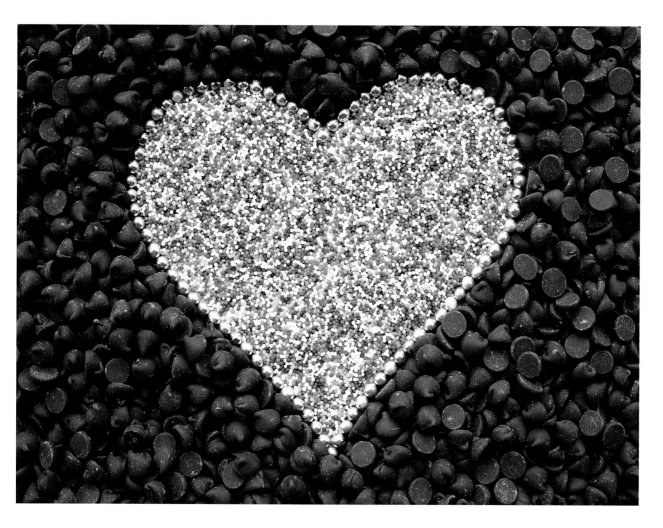

TINY KISSES

chocolate chips, metal dragées, sprinkles

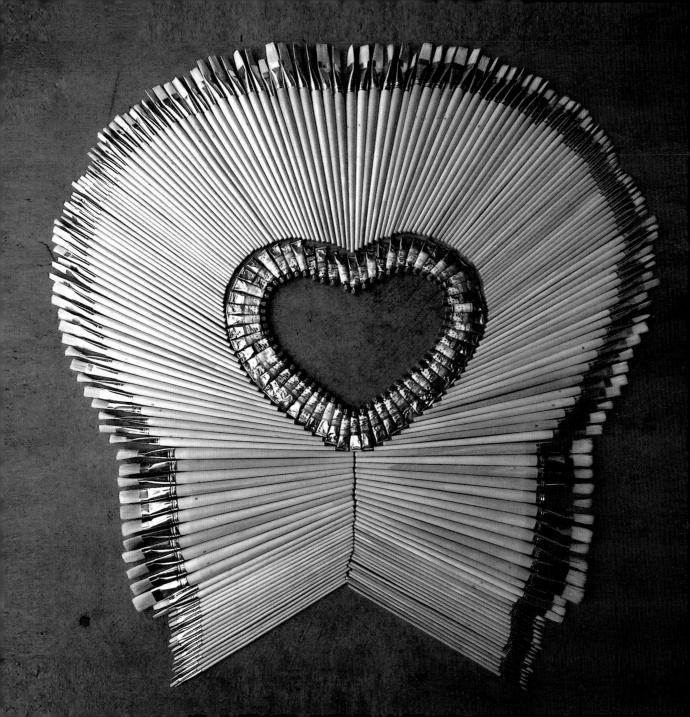

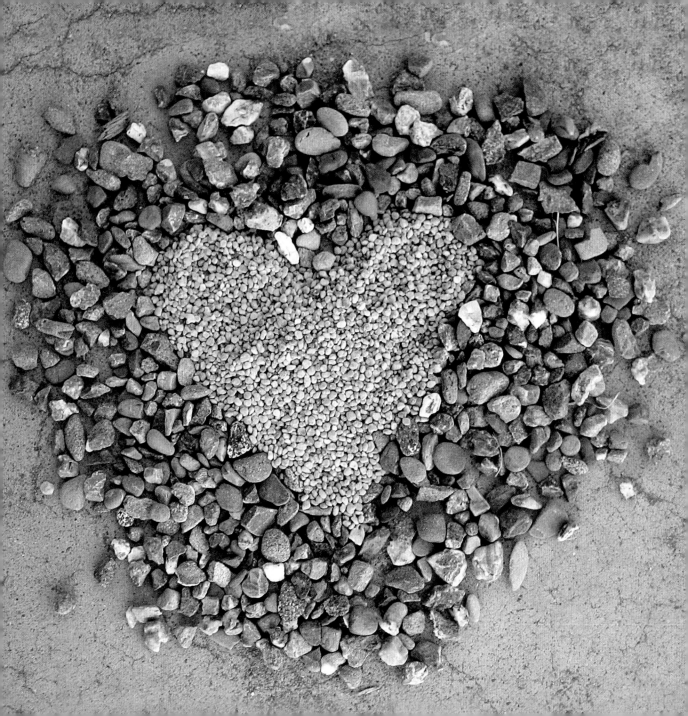

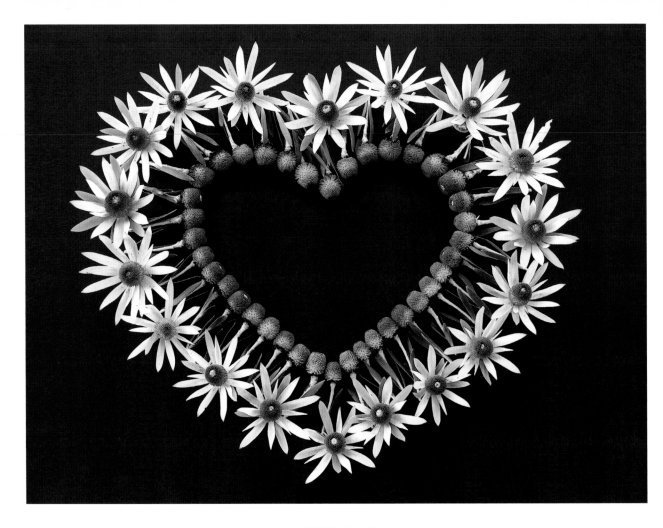

SPRING HEART
disassembled Leucadendron

❧

PREVIOUS PAGES
NATIVE PAINTER *paintbrushes, mini tubes of watercolor paint* **POLLEN AND PEBBLES** *gravel, bee pollen*

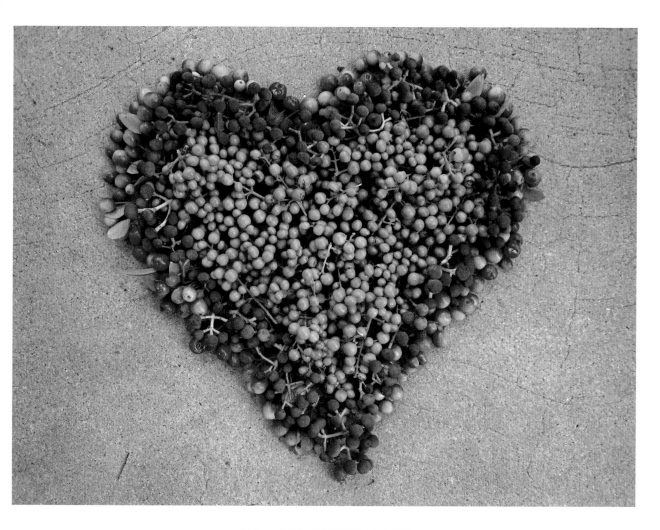

ANNA AND BENJAMIN HEART

assorted berries

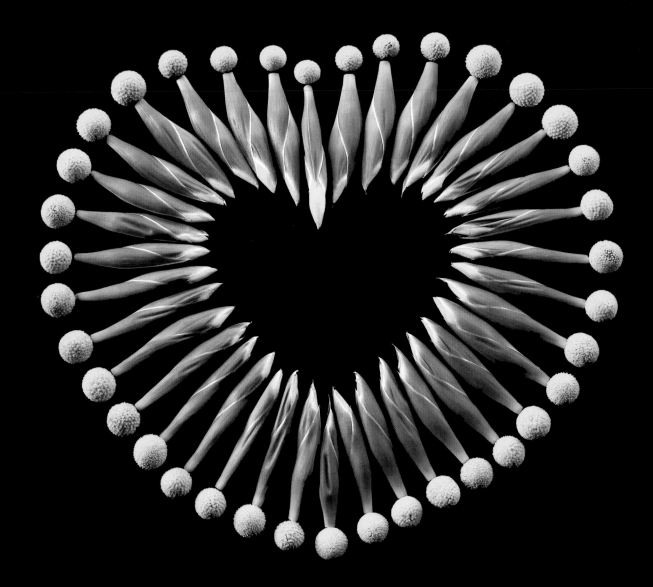

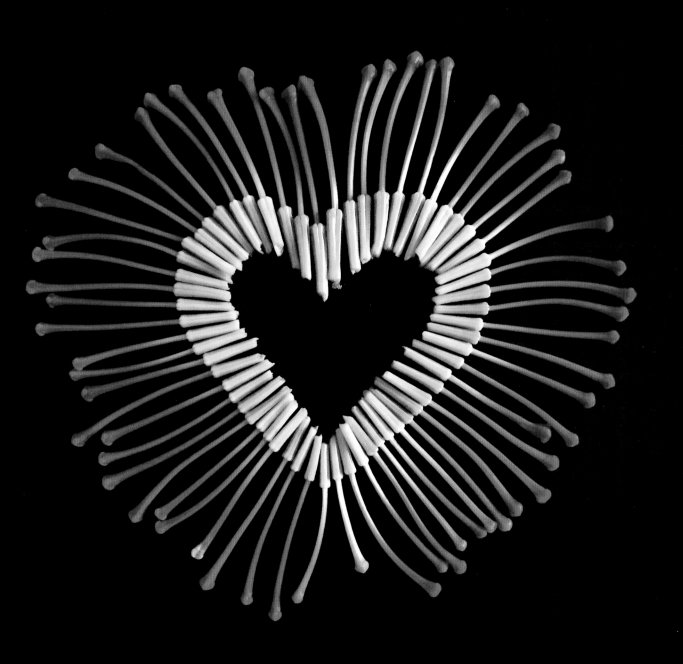

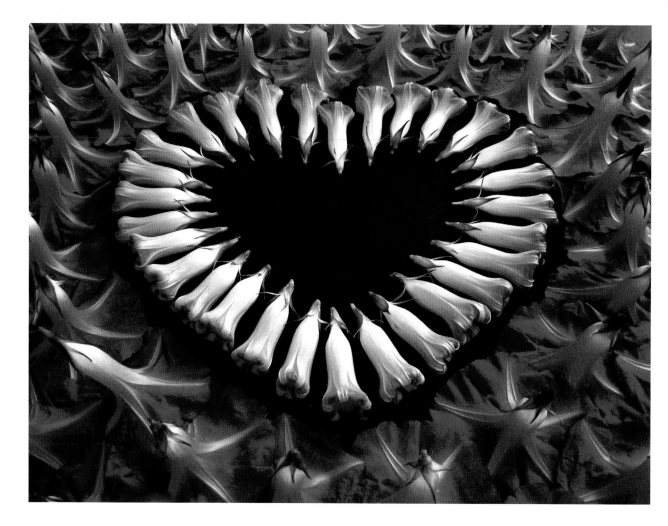

MORNING GLORY

morning glory flowers and buds

❧

PREVIOUS PAGES
YELLOW CROWN *Crespedia, iris buds* **PISTIL LION** *pistils from disassembled lilies*

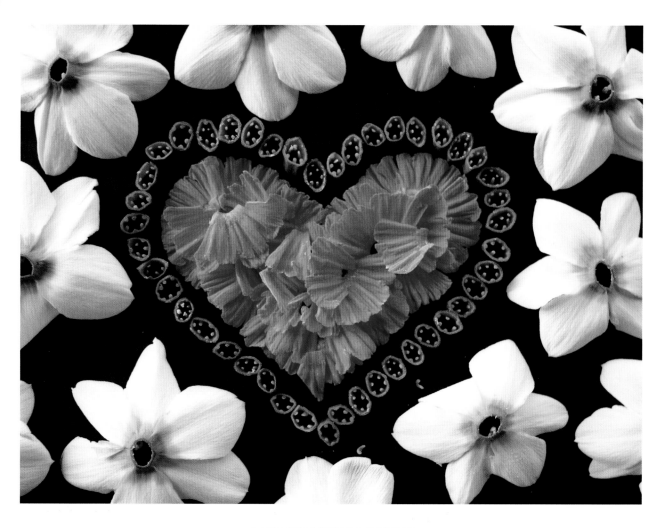

DAFFODILS UPSIDE DOWNY

upside-down, disassembled daffodils; sliced daffodil stems; daffodil petals

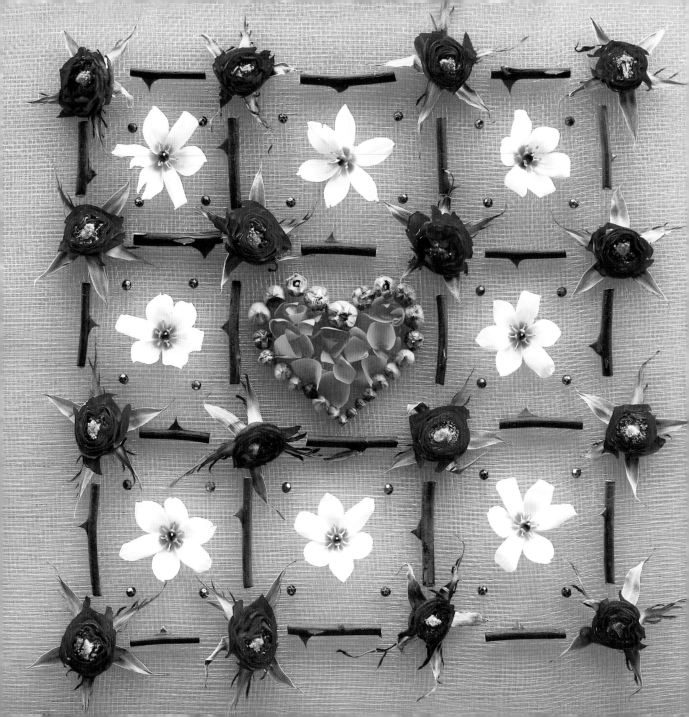

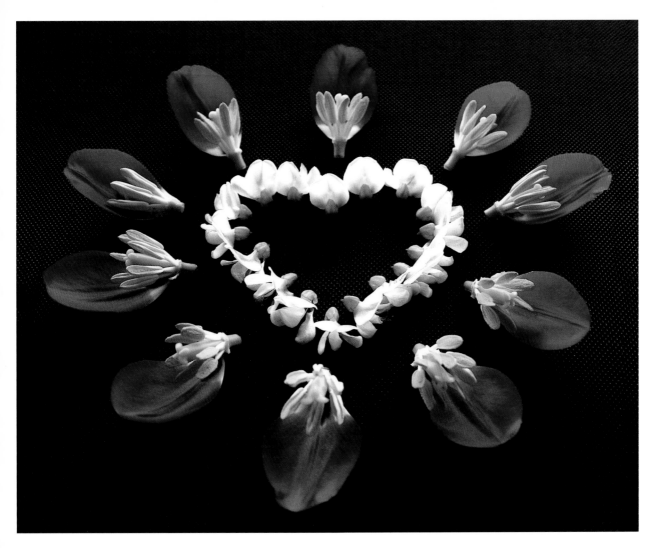

TWO LIPS
disassembled tulips, sweet pea flowers

∽

PATCHWORK HEART *sliced roses, rose stems, purple beads, lpheion flowers, buds, orange petals*

43

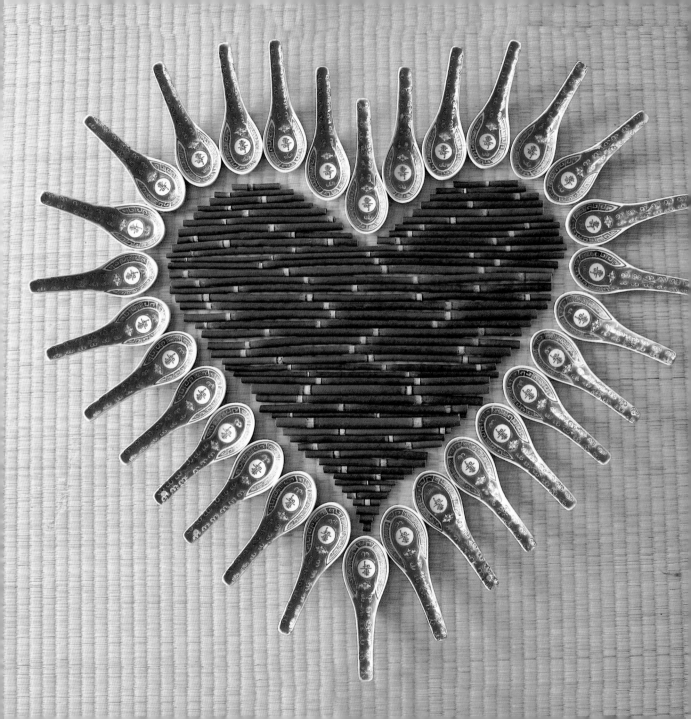

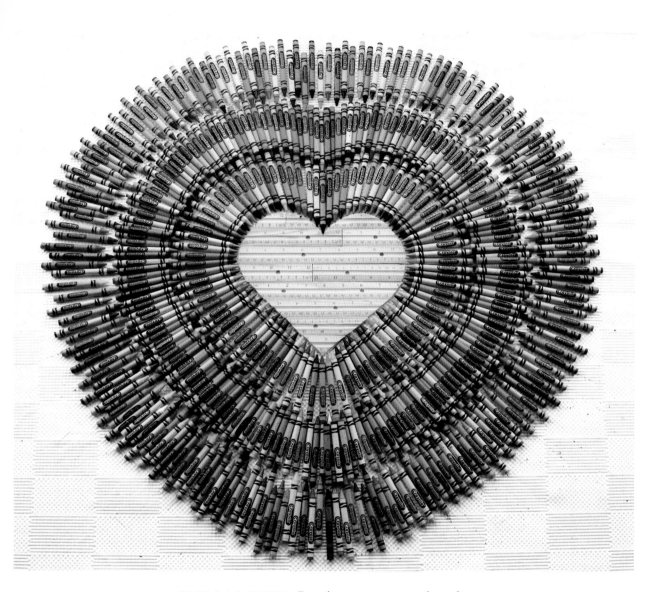

CRAY-O-LA HEART *Crayola crayons, cut wooden rulers*

CHINESE SPOONS *soup spoons and horsetails on a tatami mat*

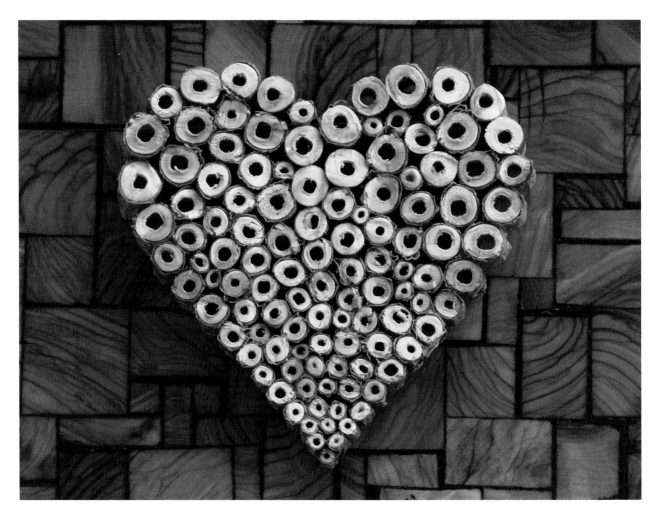

DOTS AND SQUARES

hollow stems on a wooden tray

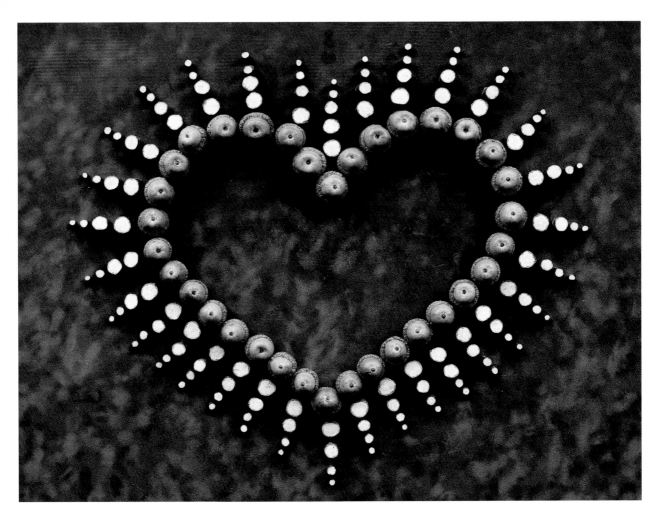

DESCENDING PEARLS
sliced branches, acorns

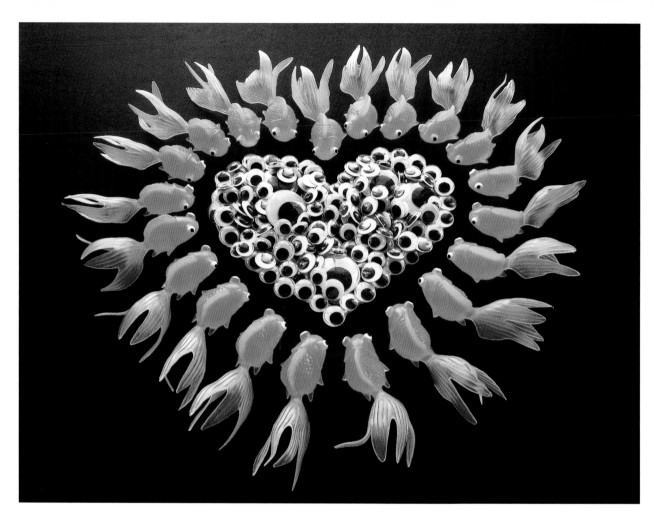

FISH ON FIRE

plastic goldfish, assorted craft eyes

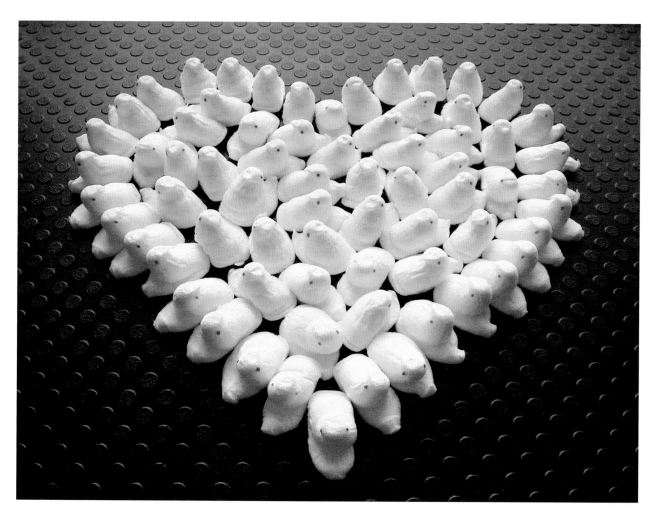

PEEPS

Peeps on a textured mat

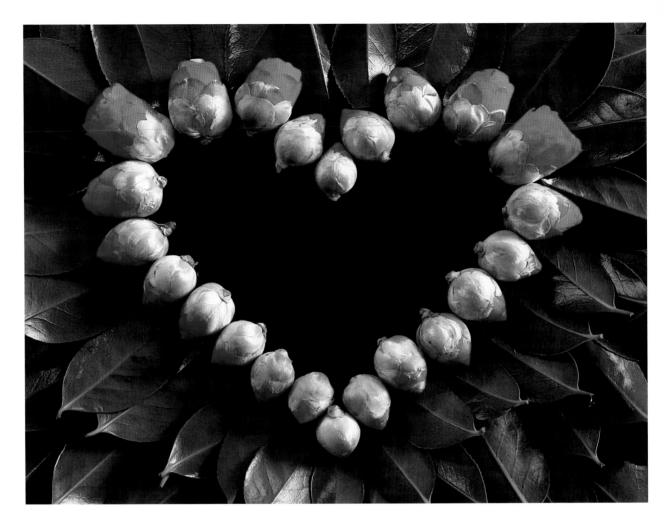

SEAN'S CAMELLIAS

Camellia leaves and buds

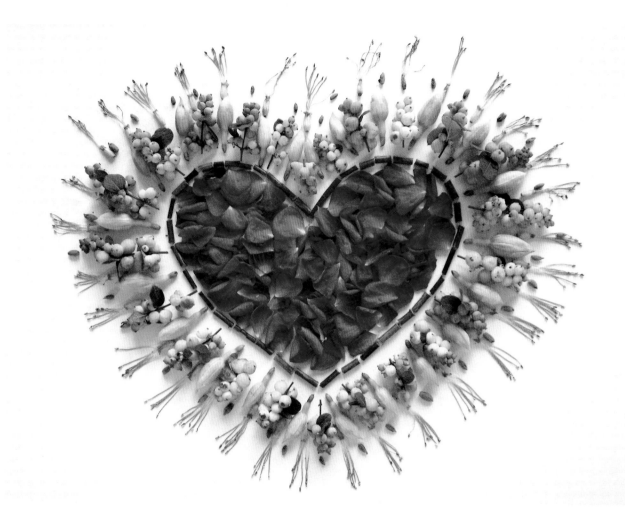

LAUREL HEART

fuchsia, pink snowberries, stems, rose petals

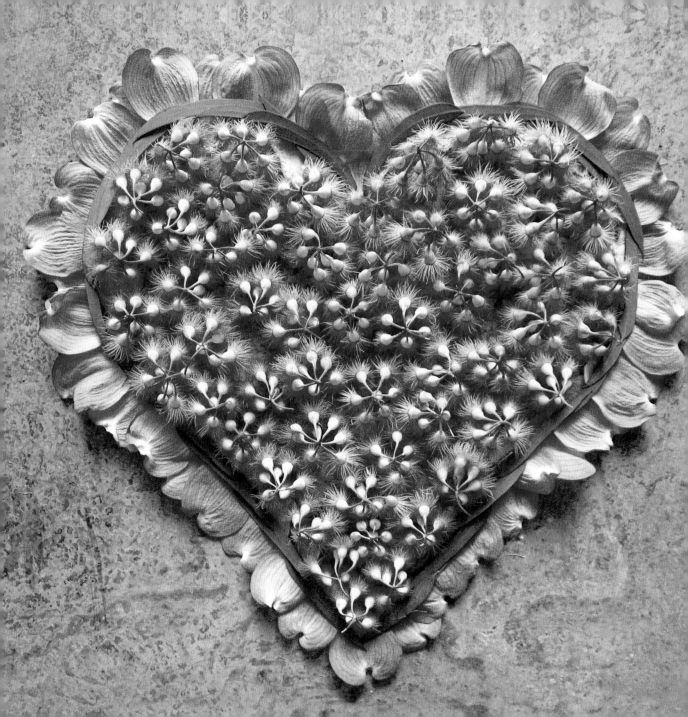

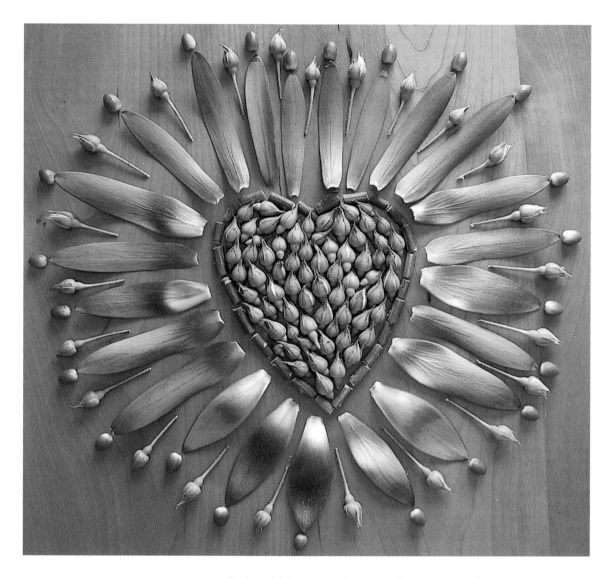

HAWAIIAN HEART *rosebuds, red Hypericum berries, Safari Sunset petals, stems*

PINK SECRET *dogwood petals, eucalyptus leaves, pink eucalyptus buds*

53

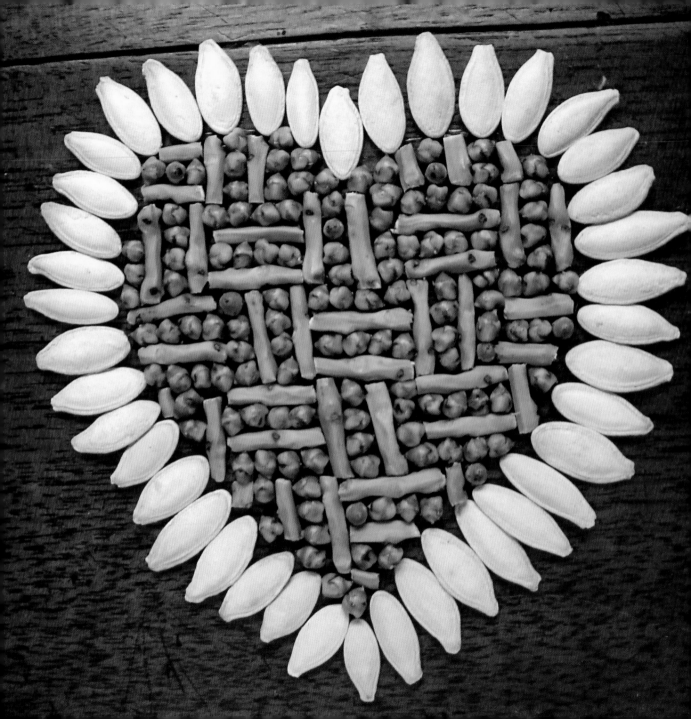

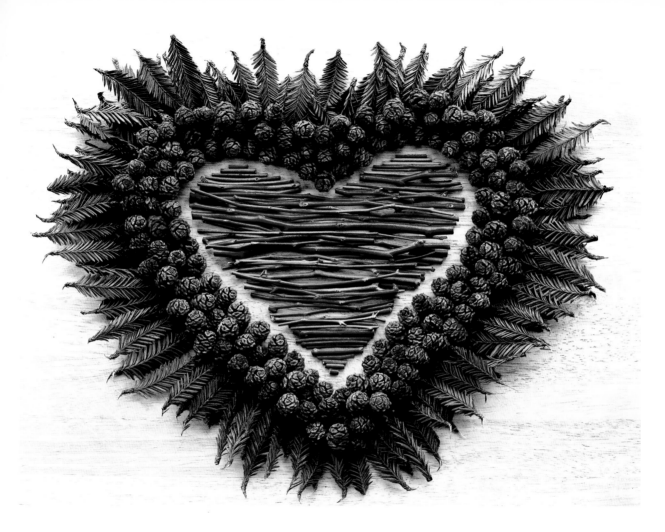

WINTER STORM
redwood foliage and cones, assorted stems

❧

SEEDS AND STEMS
pumpkin seeds, date palm stems

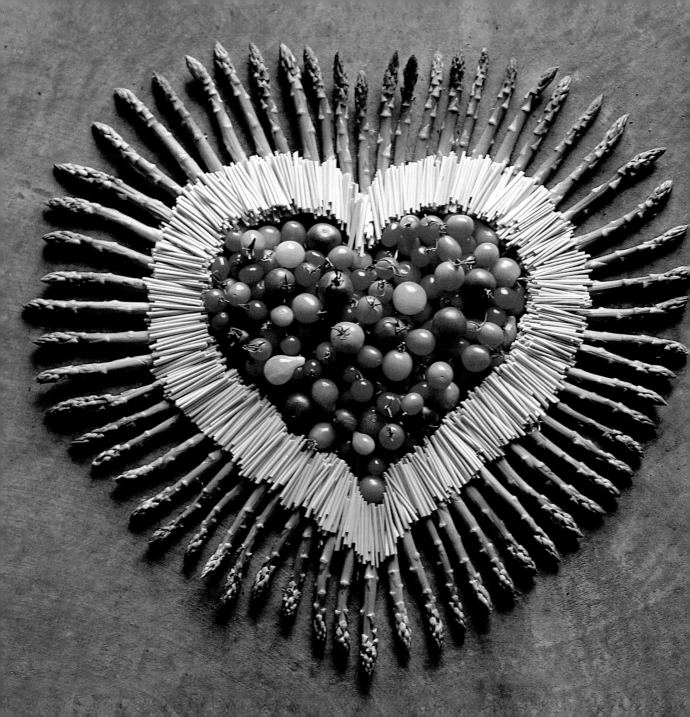

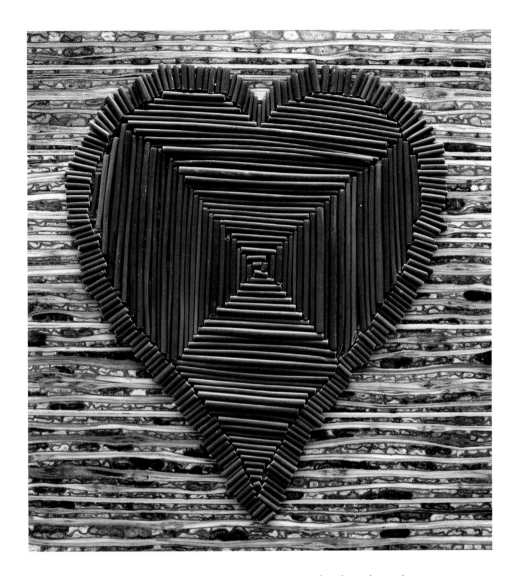

BETTY RUBBLE'S CORSET *stems on bamboo plywood*

ASPARAGUS *asparagus, straw, cherry tomatoes*

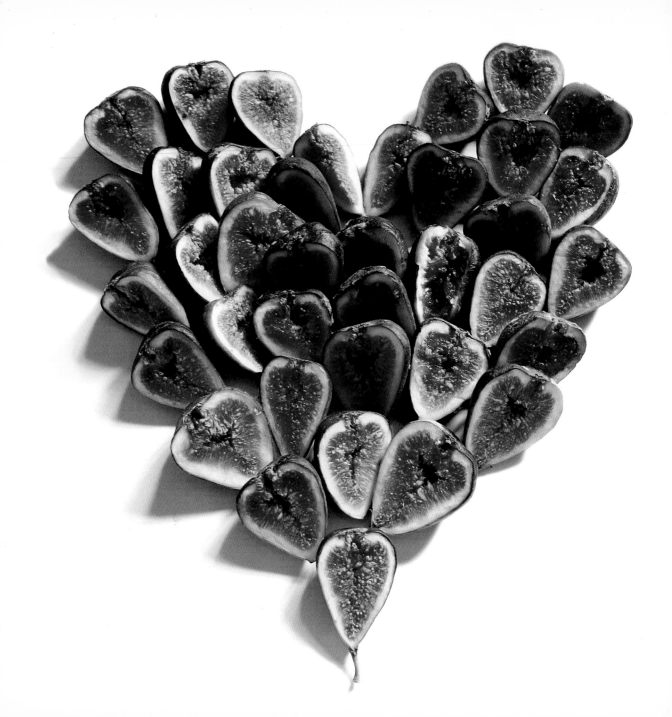

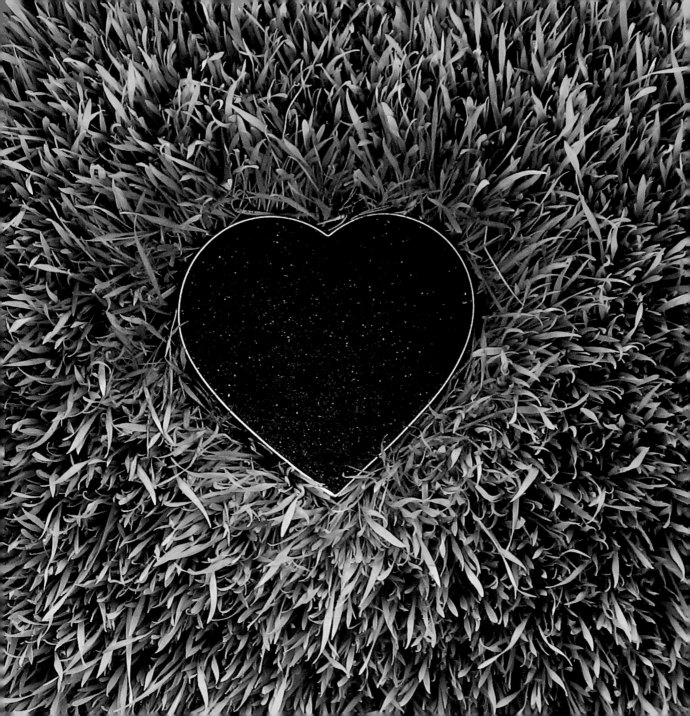

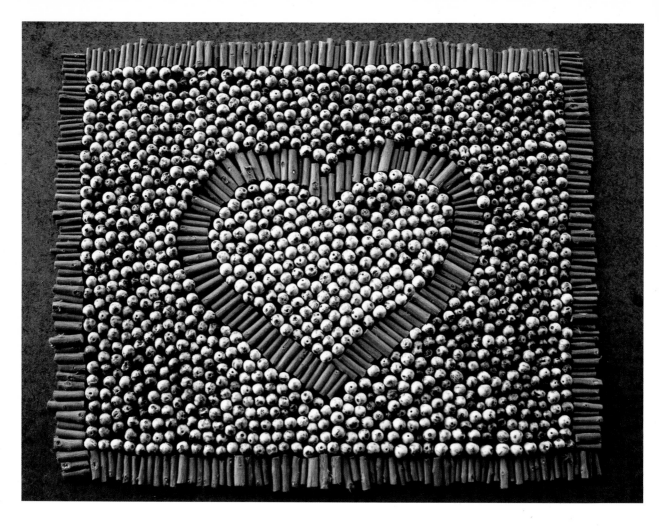

BUDDHA BERRIES HEART
wild berries and their cut stems

❧

PREVIOUS PAGES
FIGS WITH MARY *ripe, halved figs on a white platter* **LOVE OUR EARTH** *heart-shaped cookie cutter and soil on grass*

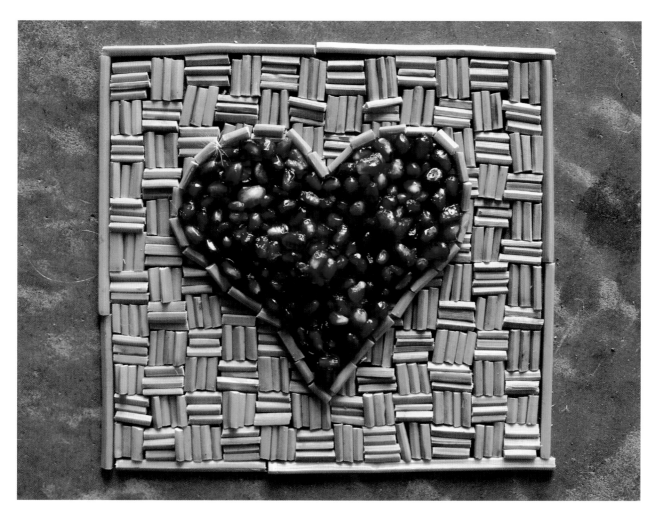

POMEGRANATE HEART

date palm stems, pomegranate seeds

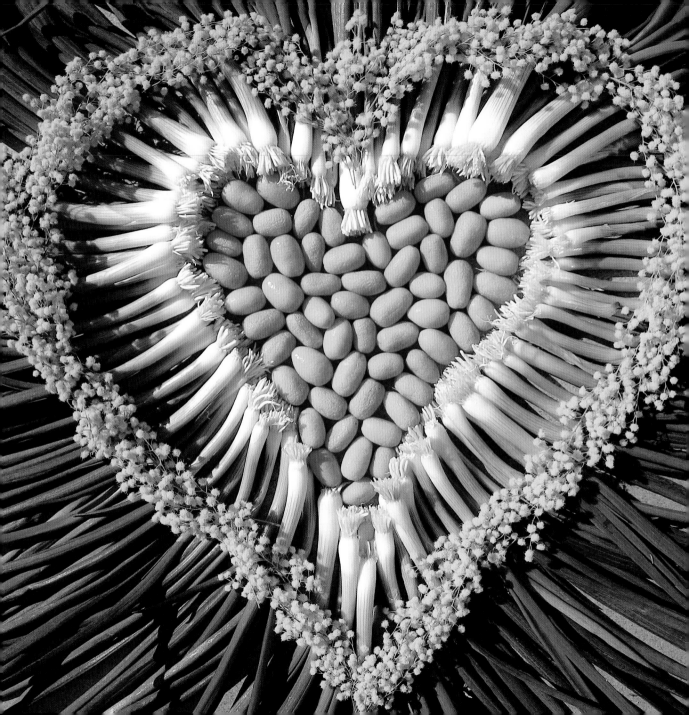

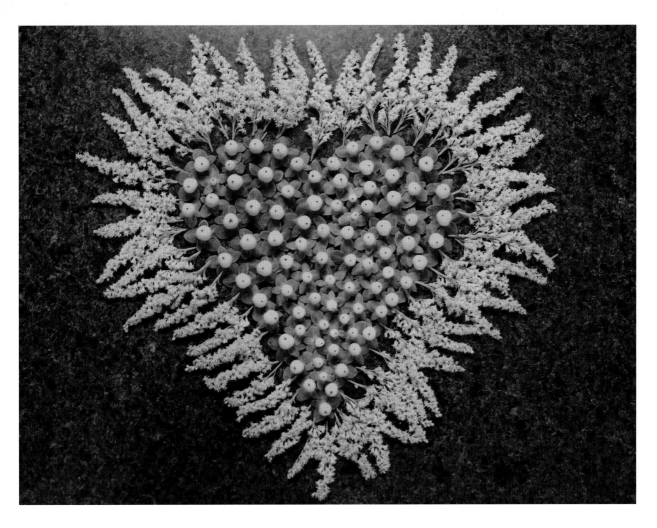

YELLOW HEAVEN

goldenrod, Hypericum berries

❧

KUMQUAT HEART

green onions, Acacia flowers, kumquats

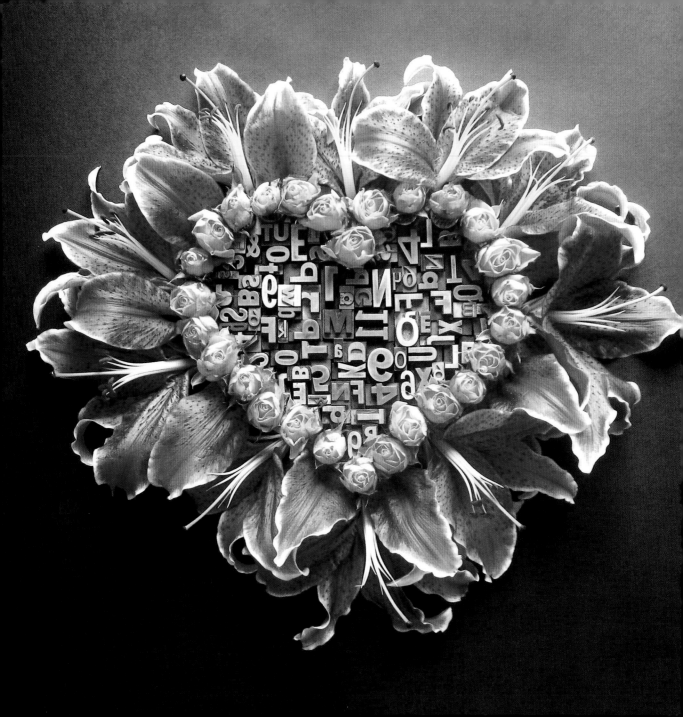

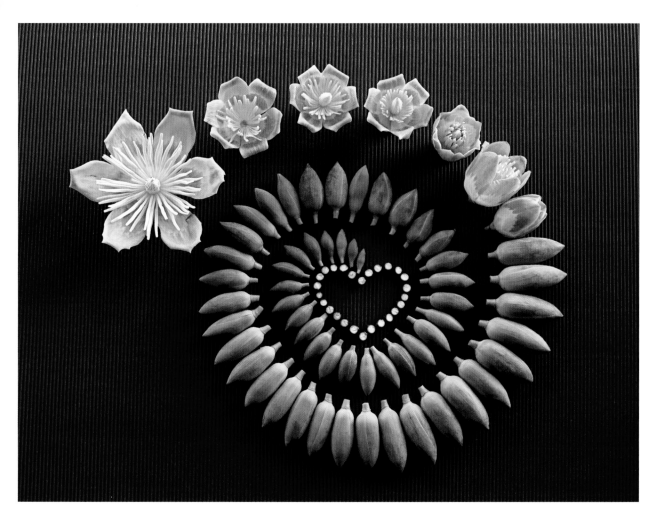

LOVEVOLUTION

tulip magnolia blossoms, buds, and cut stems

⌒⌒

LETTERPRESS HEART

Stargazer lilies, dried rosebuds, metal letterpress pieces

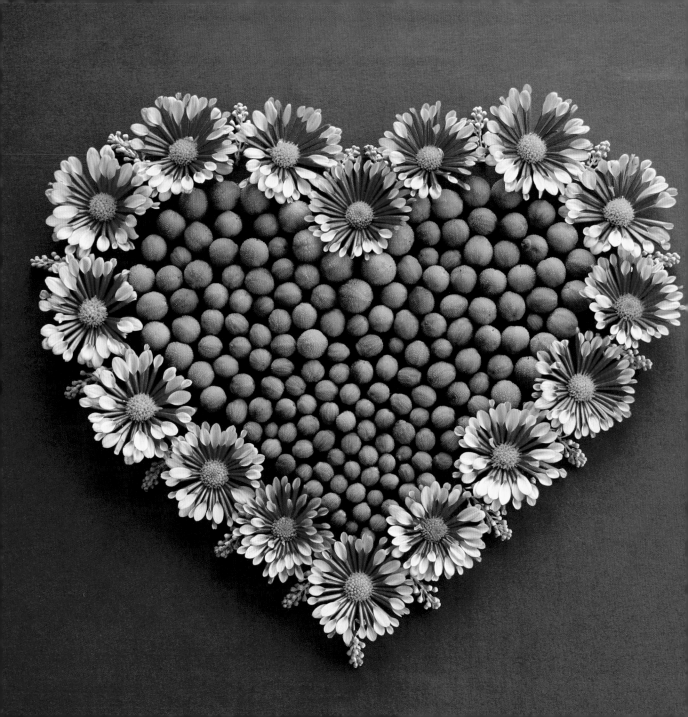

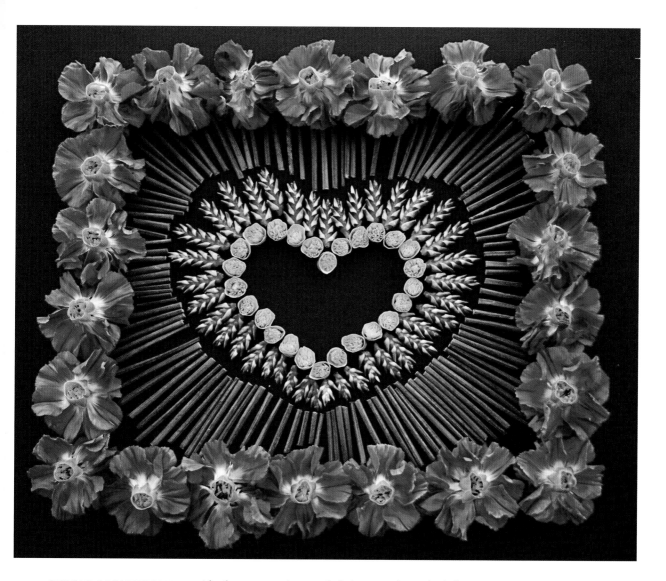

PURPLE CARNATIONS *upside-down carnations and their stems, bromeliad flowers, carnation flower slices*

⤐

RED AND YELLOW SPOONY DAISIES *white flower buds, Chrysanthemums, blushing green berries*

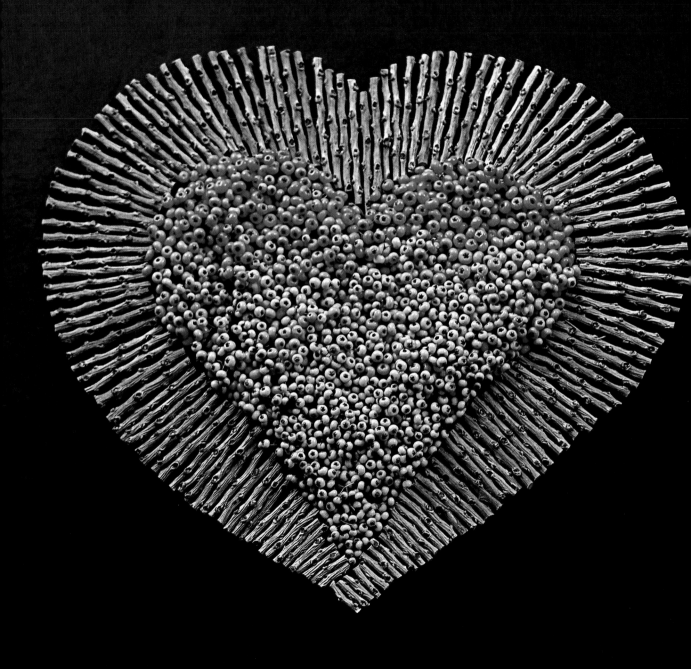

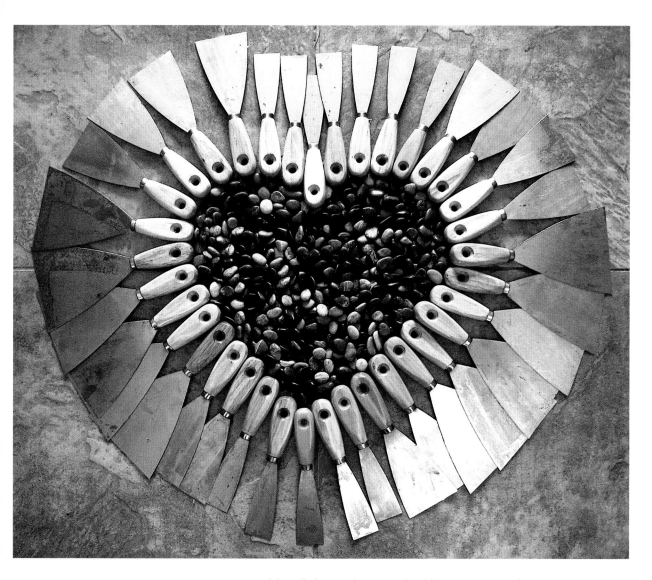

PUTTY KNIFE HEART *wood-handled putty knives and pebbles on ceramic tile*

SEASON OF CHANGE *sticks, Pyracanthus berries*

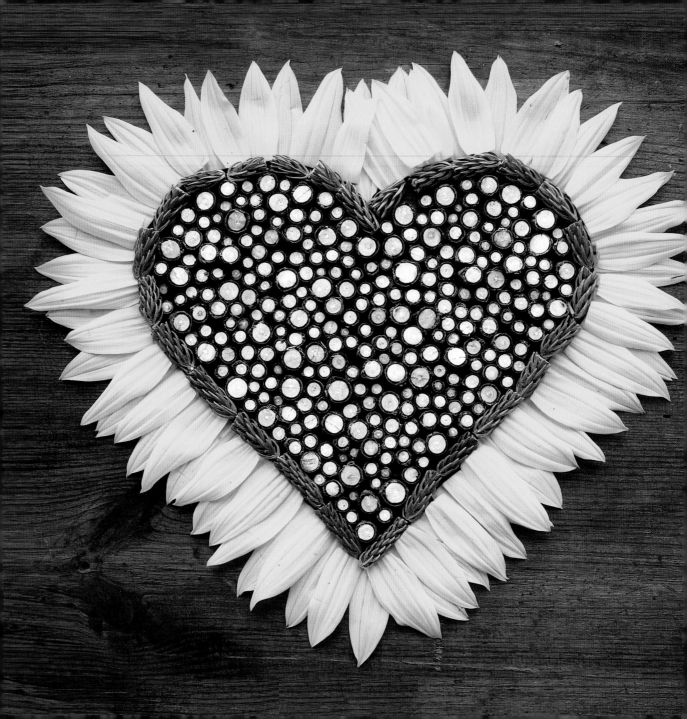

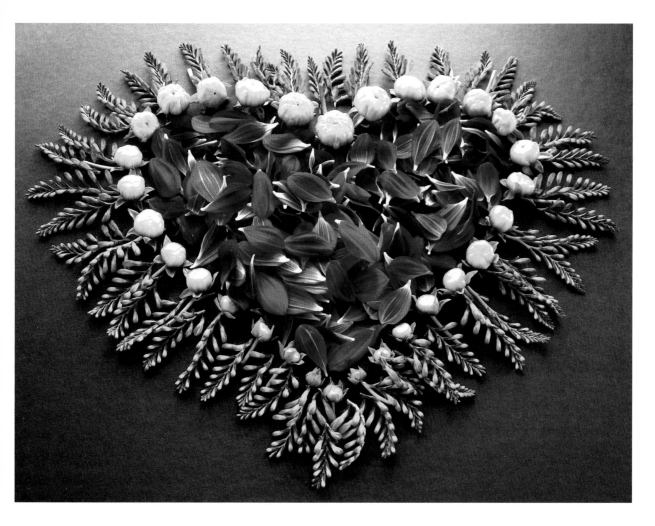

RED SEA FURY

Crocosmia buds, Ranunculus buds, dahlia petals

⁓⊚⁓

FLOWER OF THE SUN

sunflower petals, dried pine tips, cut stems

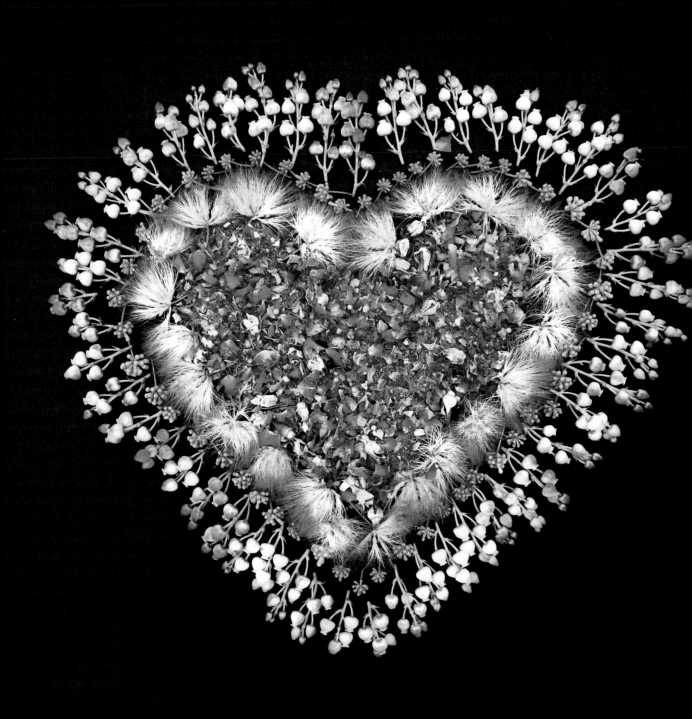

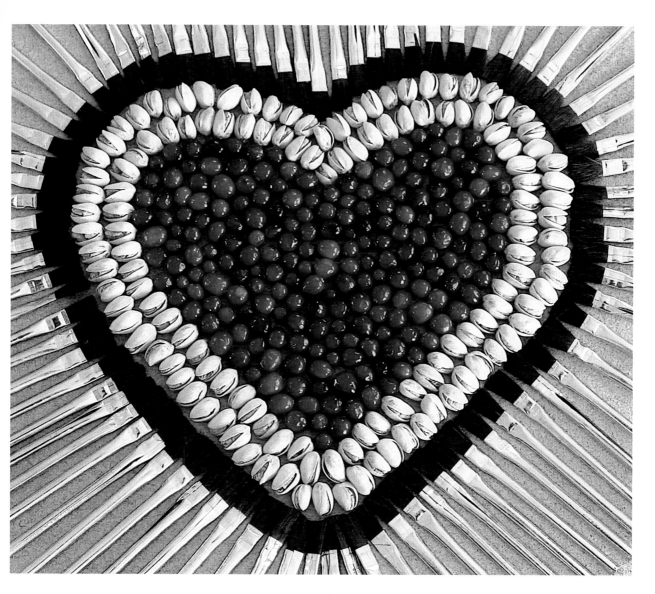

CRANBERRIES AND PISTACHIOS *metal paintbrushes, pistachio nuts, cranberries*

CHINESE LANTERN *Arbutus flowers, bottlebrush flowers, dried rose petals*

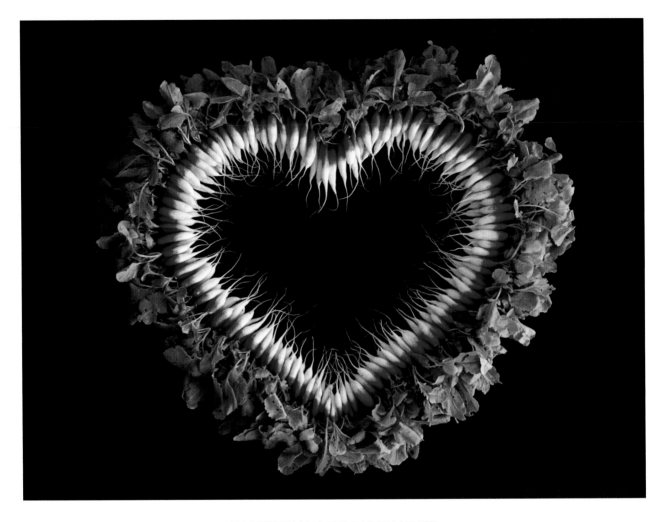

MONTEREY MARKET RADISH HEART

radish bunches with greens

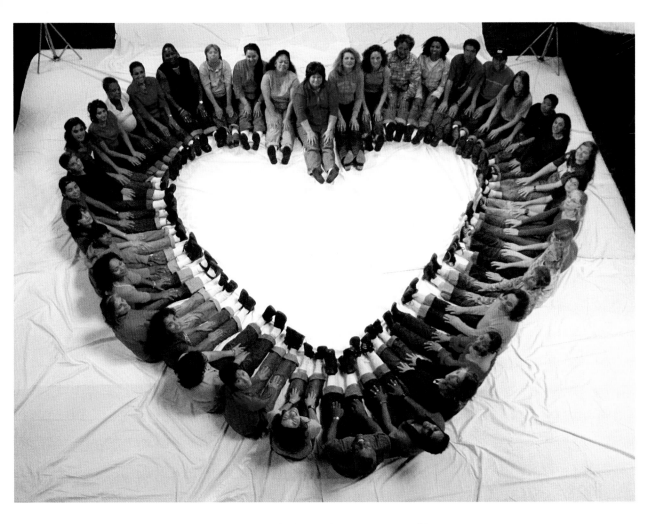

OUR TRIBE *clockwise, from top center of heart*

Anastasia Dellas, Rive Nestor, Sarah Bush, Donna De Souza, Robin Lewis, Cris Guerrero, Ivan Koshi Rodriguez, Karen Elliott,
Amy Matabuena-Lev, Ronit Matabuena-Lev, Suzanne Krivoy, Olivia Guerrero, Pam De Vore, Francesca De Vore, Vicki De Vore-Rodriguez,
Elizabeth Pritzker, Susan Schindler, Sieglinda Siggy Dawson, Lauren Hewitt, Carmen Morrison, David Spinman Salomón, Valeria Lannes,
Liz Gonzales, Elena De Vore-Rodriguez, Amanda Navarro, Roberta Goodman, Jilchristina Vest, Richelle Donigan, Cecilia Rojas,
D. Jes Montesinos, Joan Antonuccio, Juliette Leonore Delventhal, Alice Gould, Shikira Porter (with baby Omari on the way),
Michelle Porter, Karen M. Roberts, Marilee Maertz, Beatrice Fanning, Dovalyn Nohealani Hiram

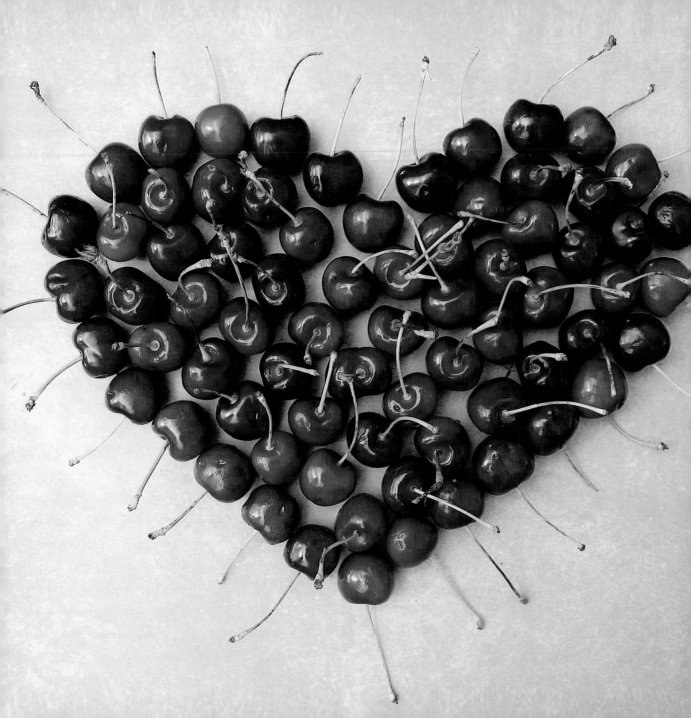

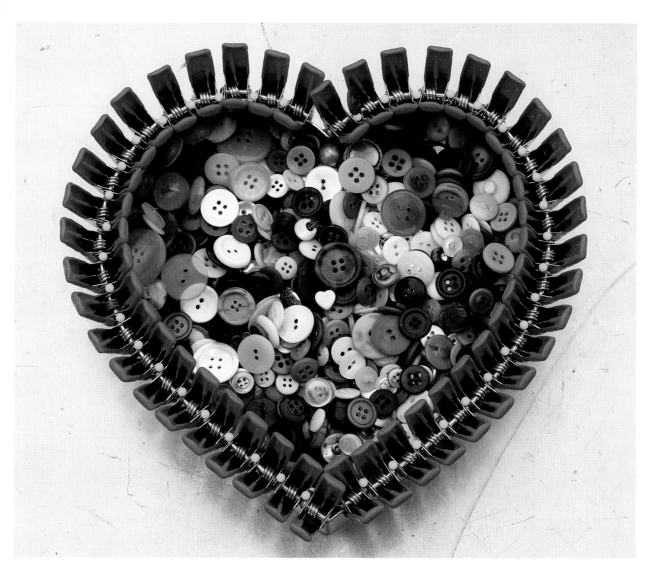

ORANGE CLAMP HEART *mini clamps attached to a metal cookie cutter, yellow-tipped hatpins, assorted buttons*

CHERRY HEART *summer cherries on tile*

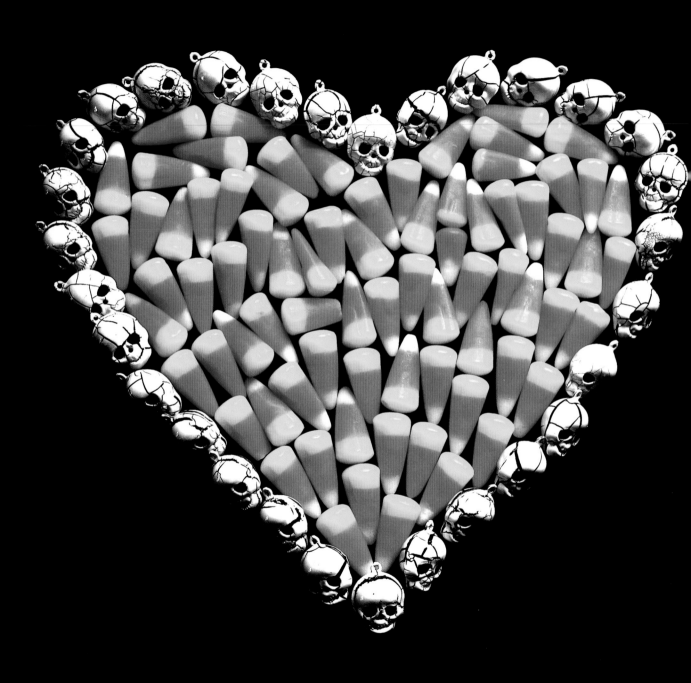

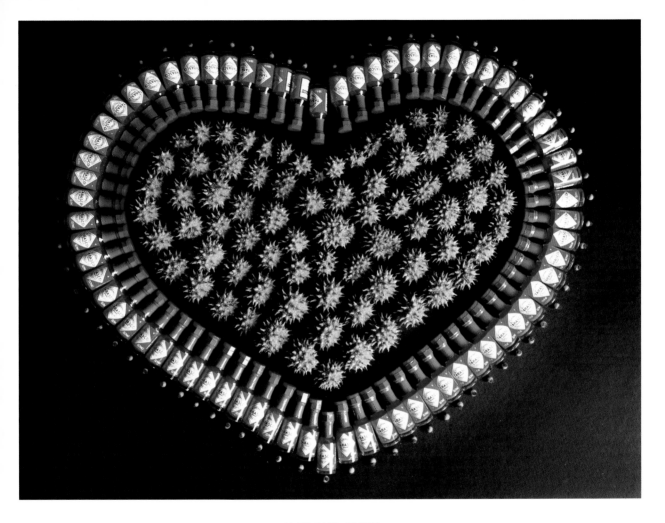

HOT AND SPIKY

mini Tabasco bottles, sweet gum seed pods

SPOOKY HEART

metal skull charms, candy corn

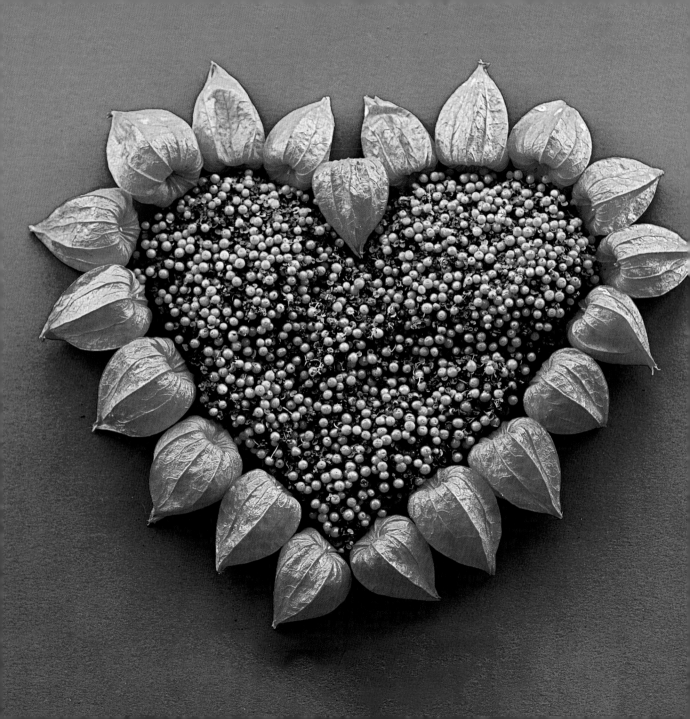

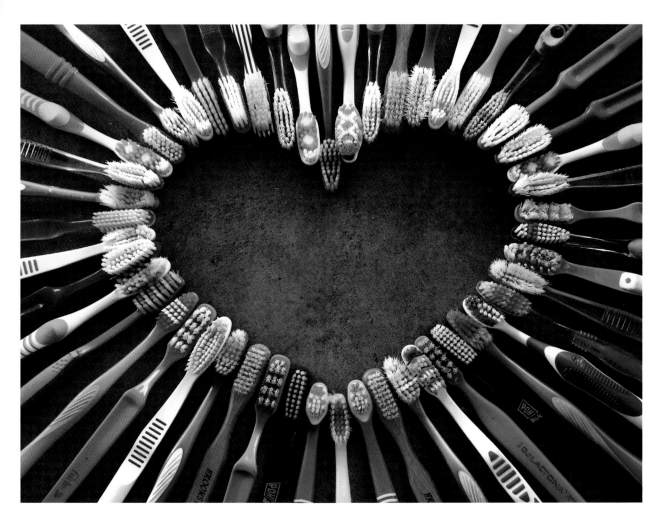

TOOTHBRUSH HEART
assorted toothbrushes

～◦～

ORANGE PINCUSHION HEART
dried Japanese lantern flowers, Nertera granadensis

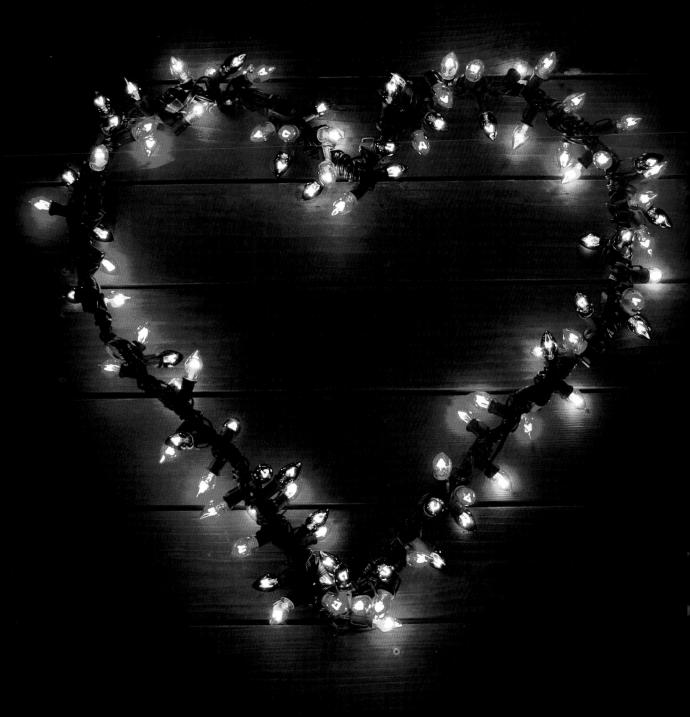

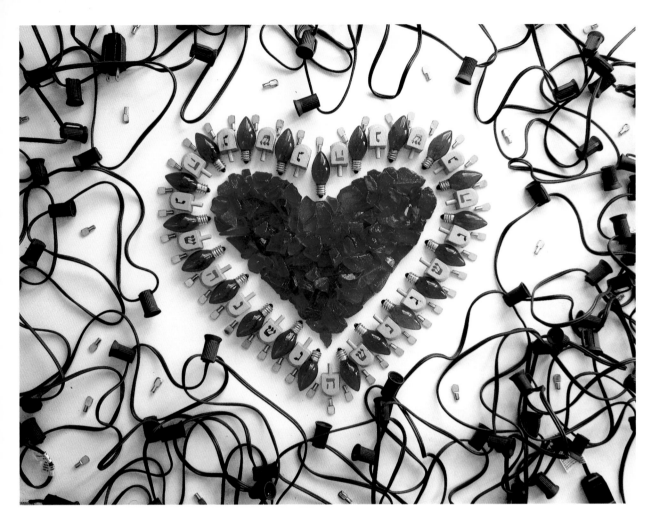

HOLIDAY HEART

light strands, brass shelf tabs, lightbulbs, wooden dreidels, broken glass

~⚬~

CHRISTMAS GLOW

strand of lights on redwood deck

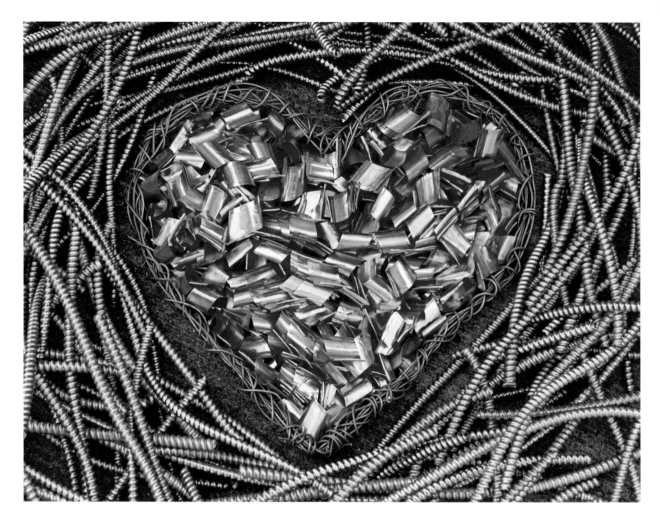

COPPER HEART

electrical Romex conduit, baling wire, copper shavings

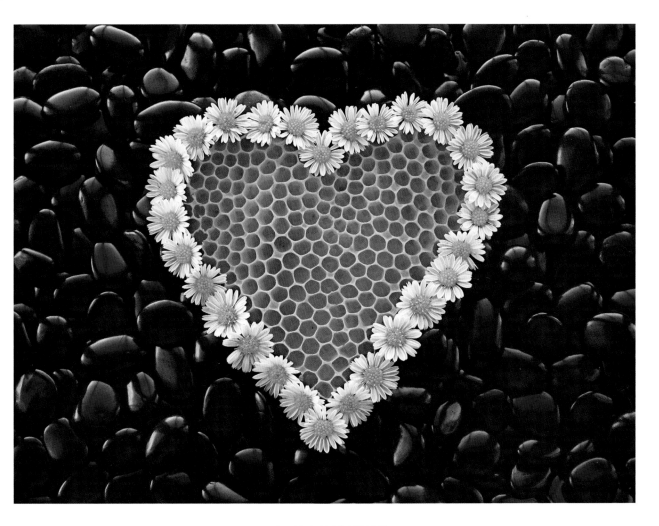

HONEYCOMB HEART

stones, daisies, honeycomb

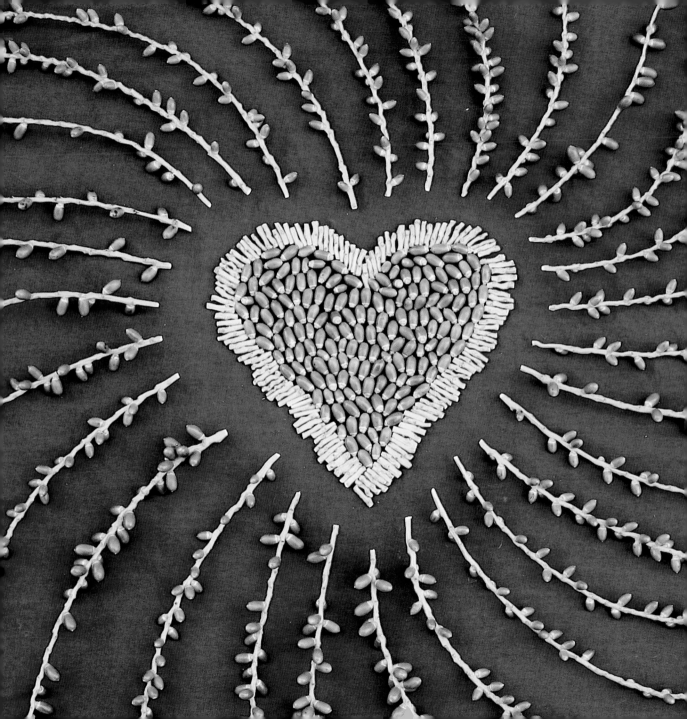

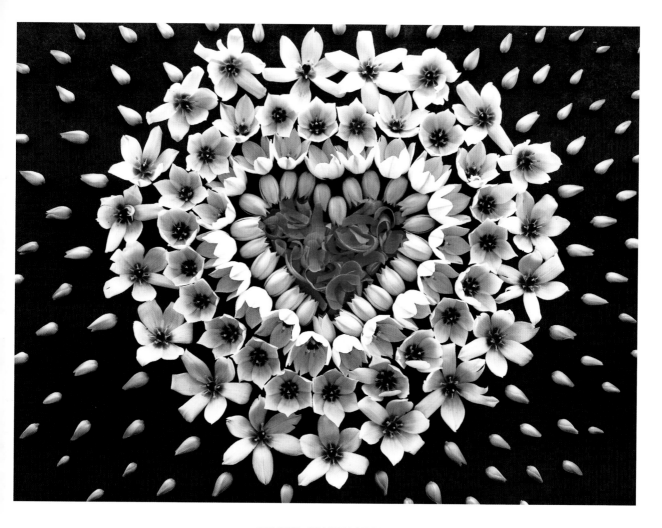

STARRY, STARRY NIGHT

Ipheion buds and flowers, Ranunculus petals

❧

HEARTSWIRL

date palm stems and berries

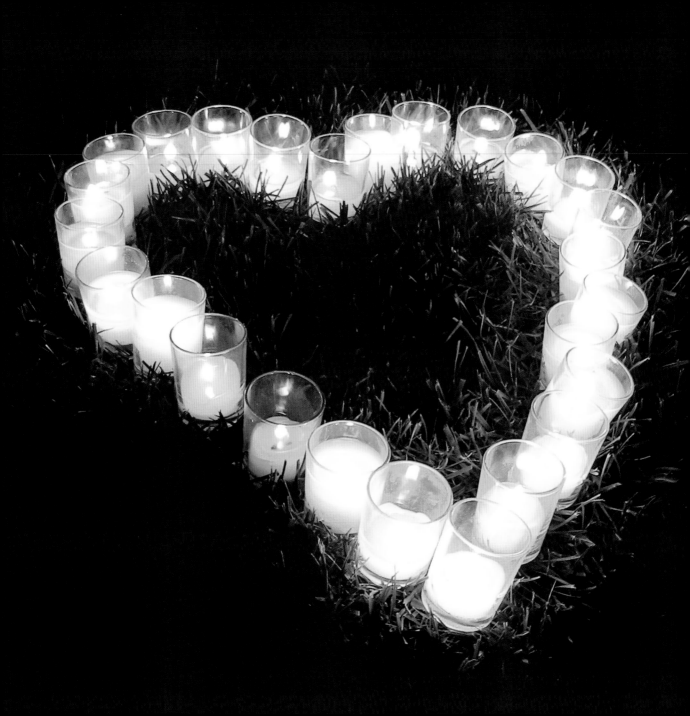

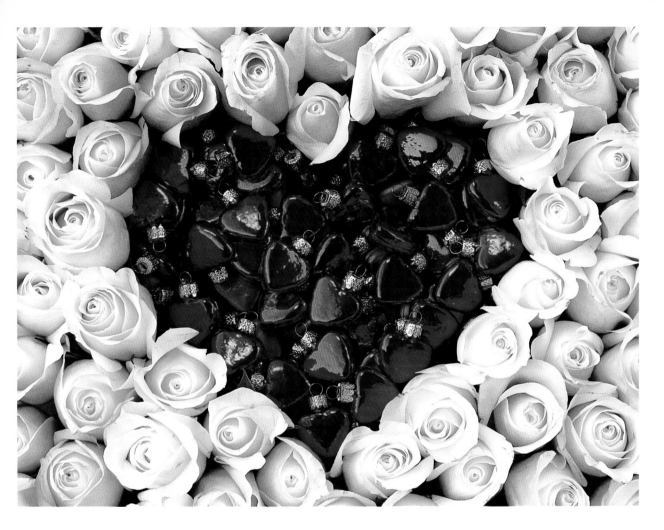

LUSCIOUS PASSION

roses, heart ornaments

~∞~

BIRTHDAY IN THE NIGHT SKY

votive candles in glass jars on lawn

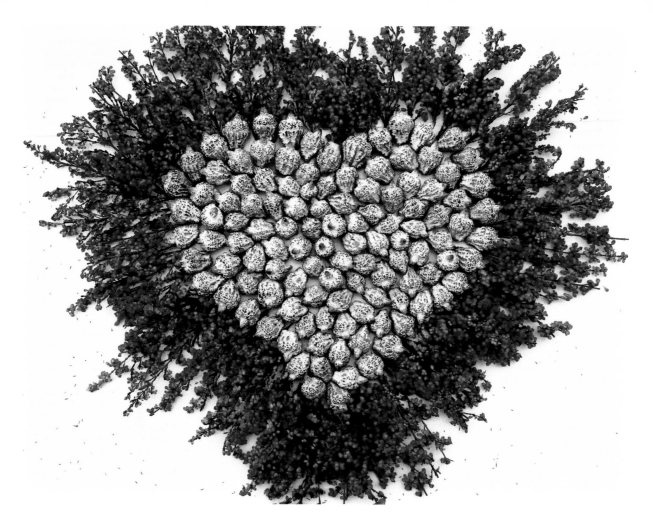

WINTER DRIVE
heather, eucalyptus buttons

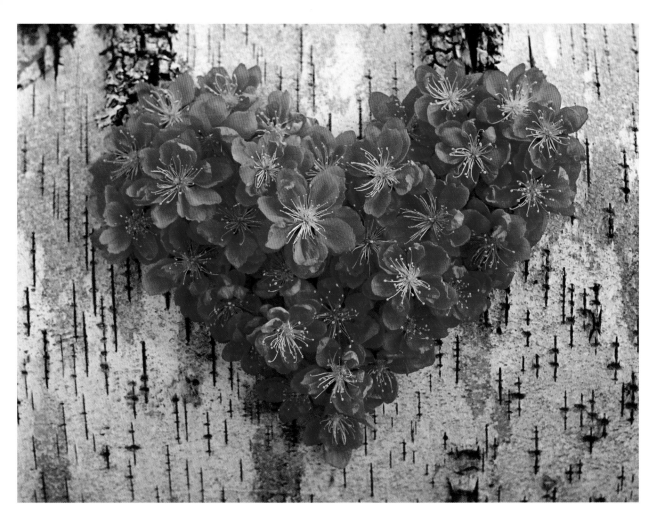

BIRCH BARK BLOSSOM

cherry blossoms on birch bark

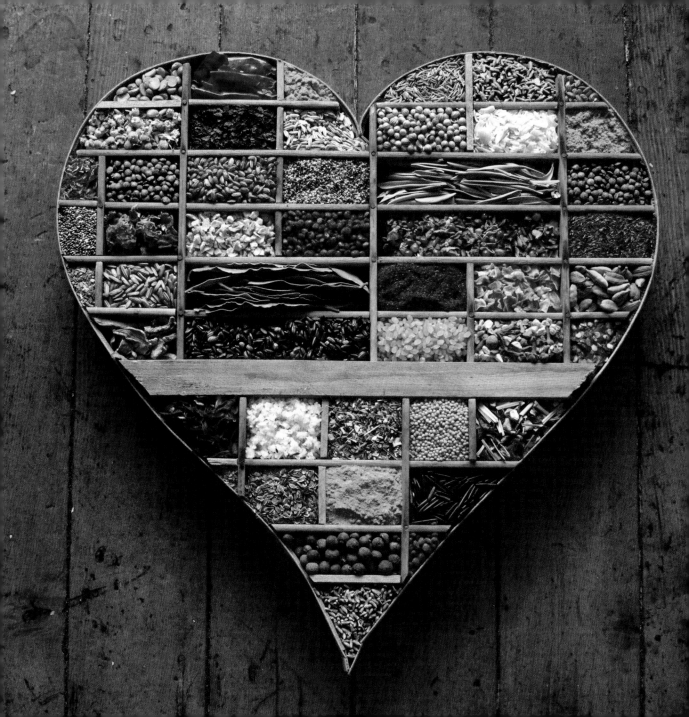

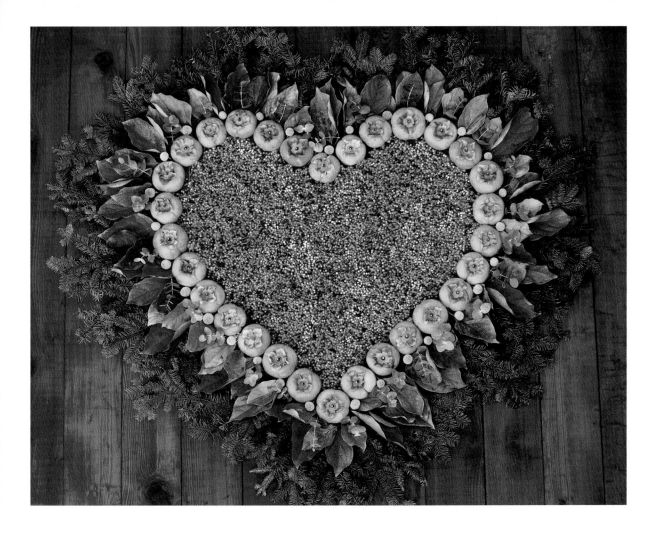

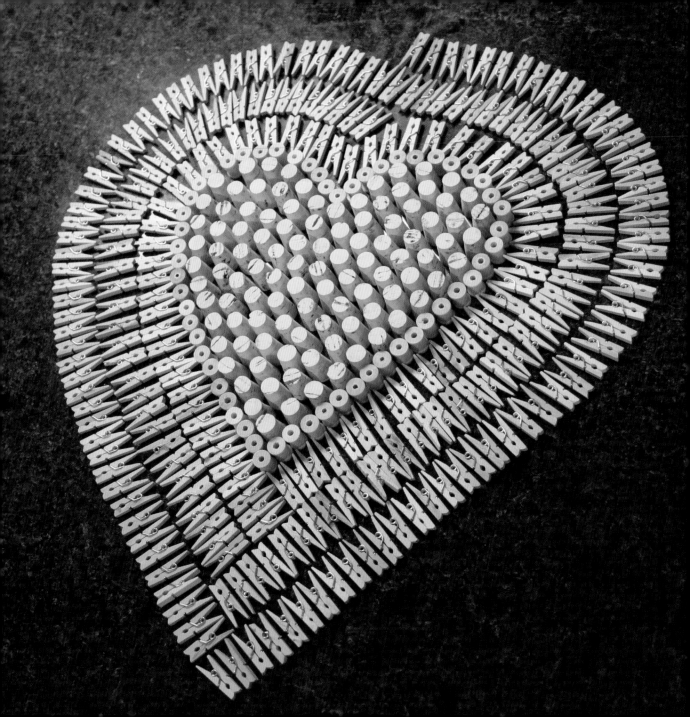

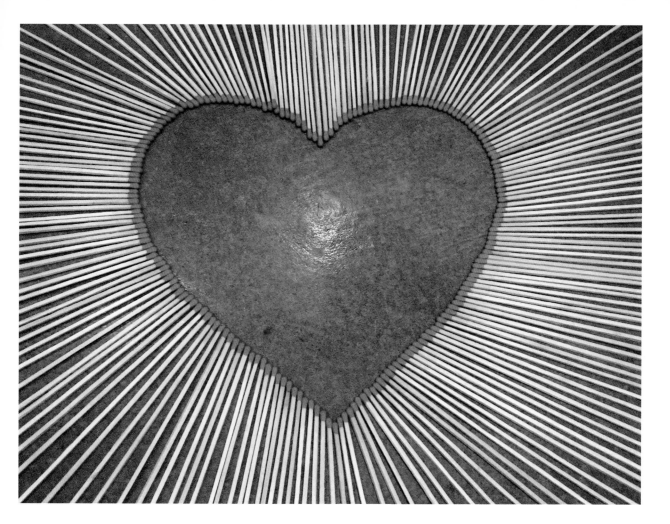

IT'S A NEW DAY
long wooden matches on concrete floor

❧

TINY WOOD
mini clothes pins, mini thread spools, mini corks

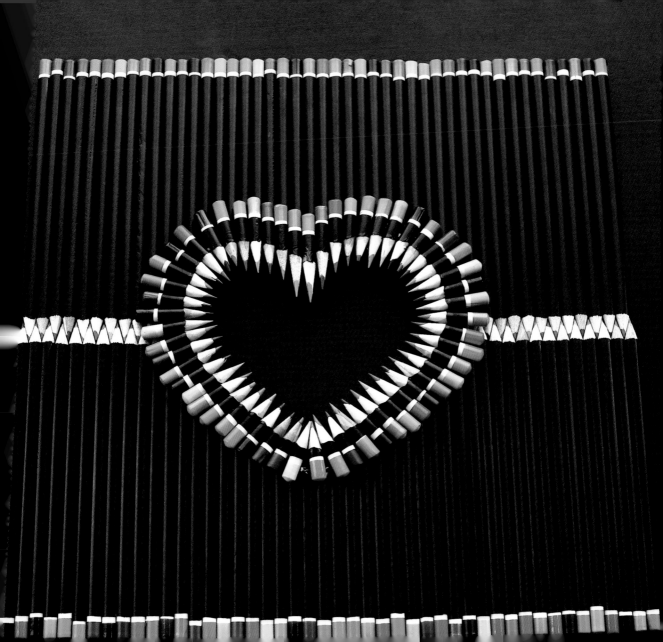

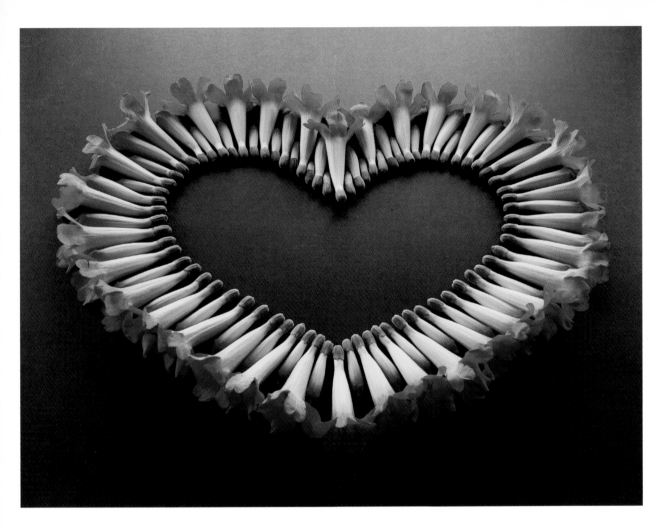

TRUMPET CHOIR
trumpet vine flowers and buds

~∾∾~

TINY PENCIL RAINBOW
colored pencils sharpened to various lengths

97

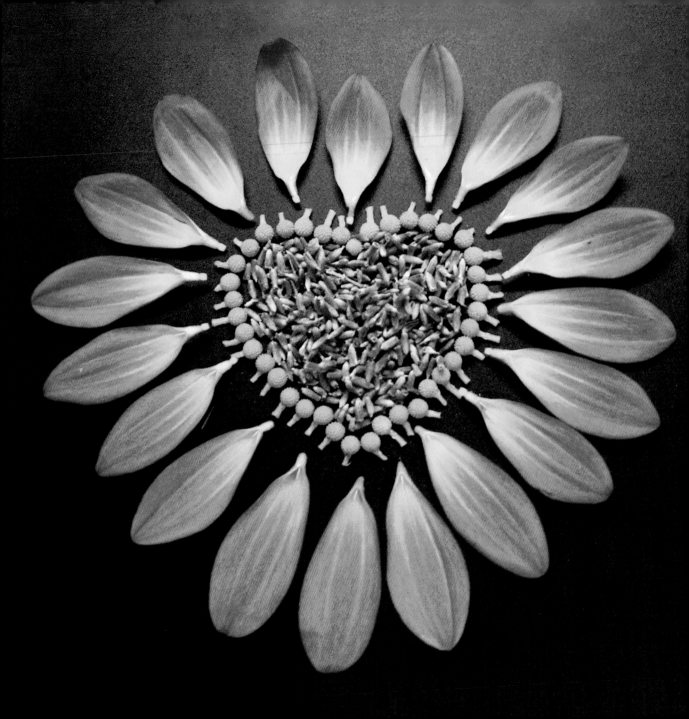

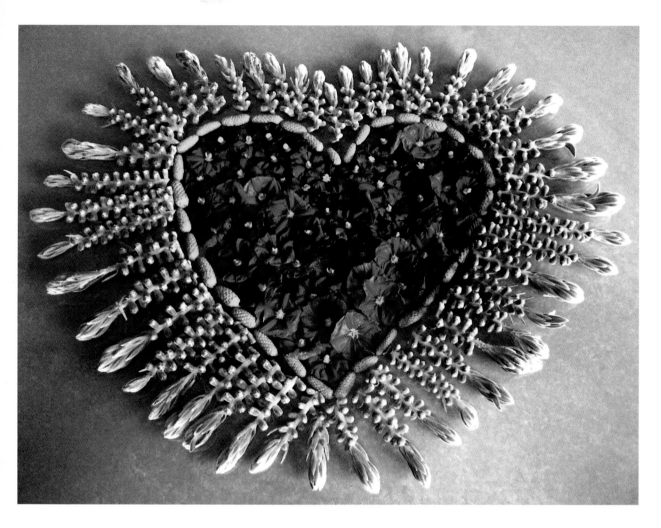

MIRABEL HEART

bottlebrush buds, pinecone seeds, African violets

❧

PINKY

Gerbera daisy petals, Boronia, Mexican sage

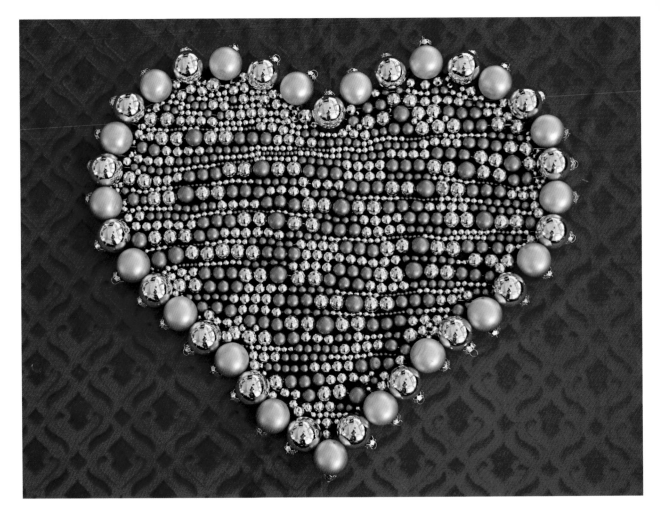

GOLDEN BOULDER CHRISTMAS

tree ornaments and bead strands on a velvet tree skirt

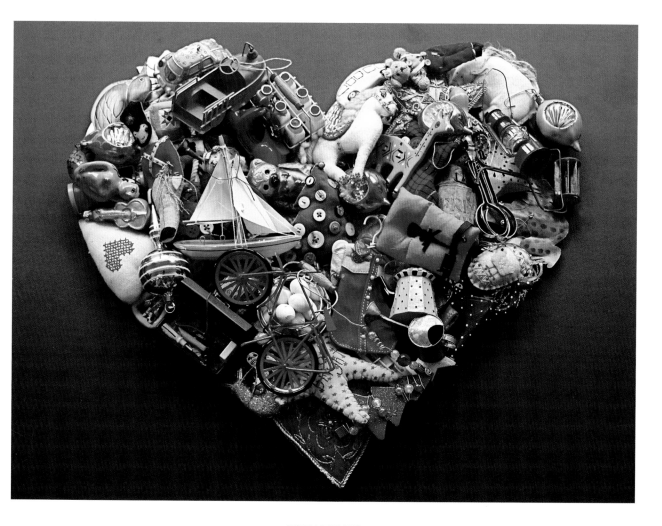

ORNAMENTS

my collection of Christmas tree ornaments

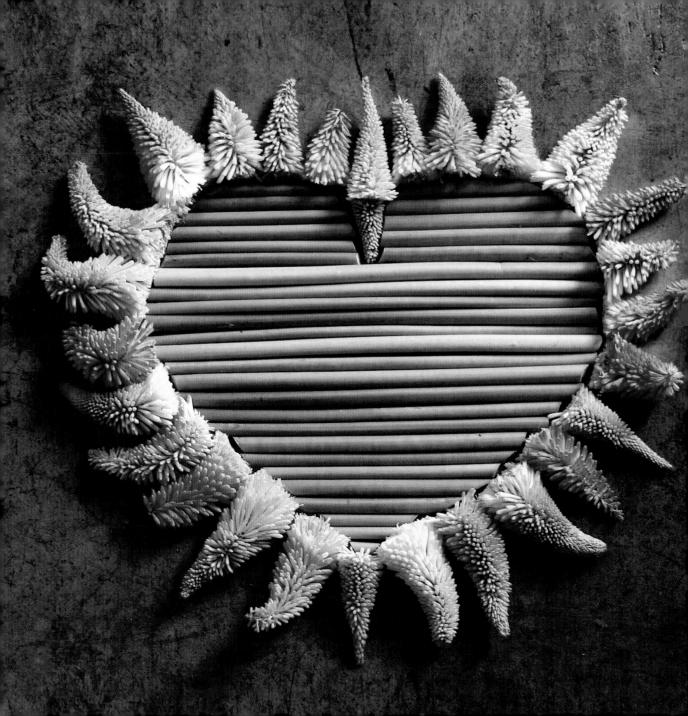

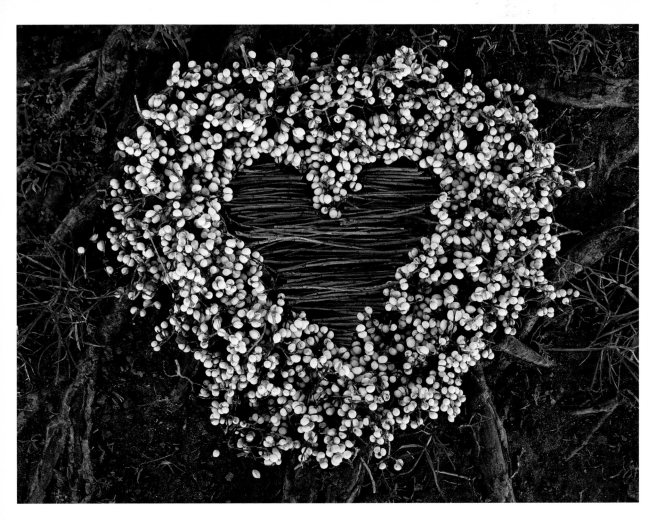

HEART BENEATH A TREE

tallaberry and sticks on tree roots and soil

~⚬~

FIERY STARFISH

Kniphofia flowers, calla lily stems

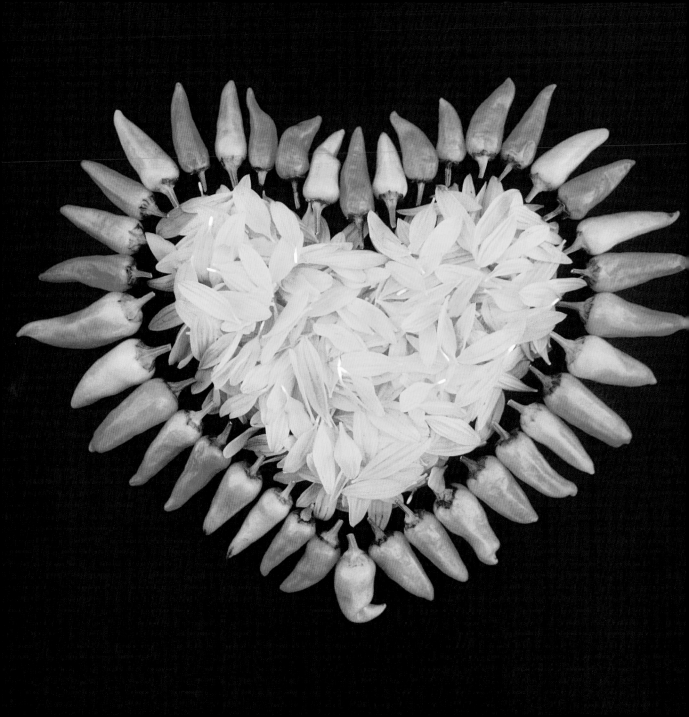

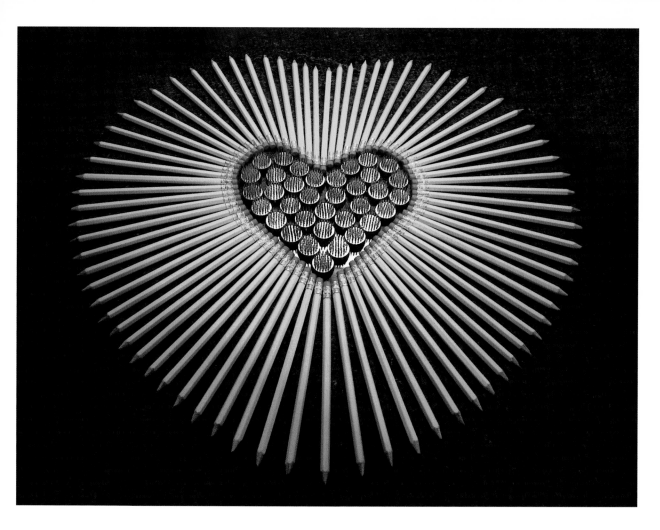

PENCIL SUN

No. 2 pencils, florist flower frogs

❧

HEART OF GOD

jalapeño peppers, sunflower petals

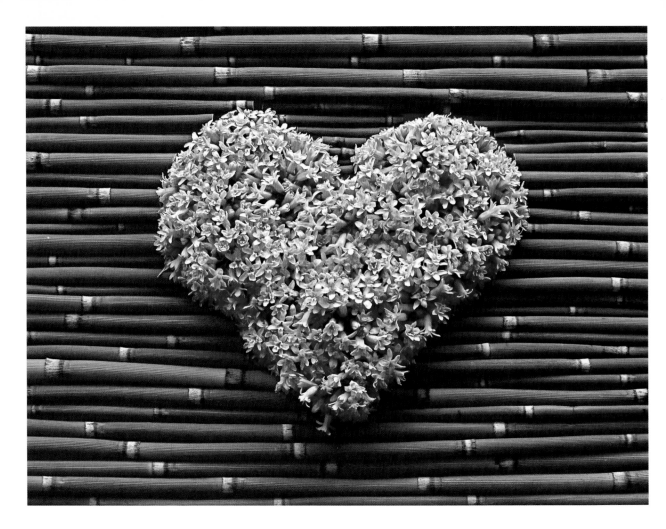

SWEET PINKNESS

lilacs on horsetails

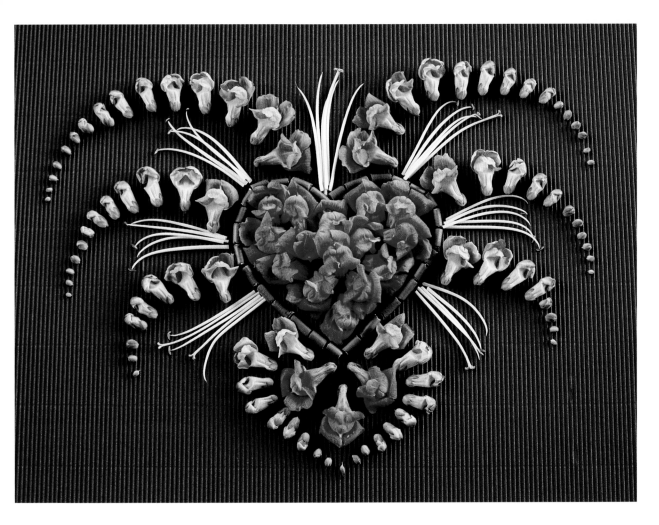

DRAGONS CASCADING

disassembled snapdragons and their stems

⁓ꝫ

FOLLOWING PAGE
RAINY TULIPS *iris buds, parrot tulips* **TOGETHER FOREVER** *rose buds, lavender, rose petals*

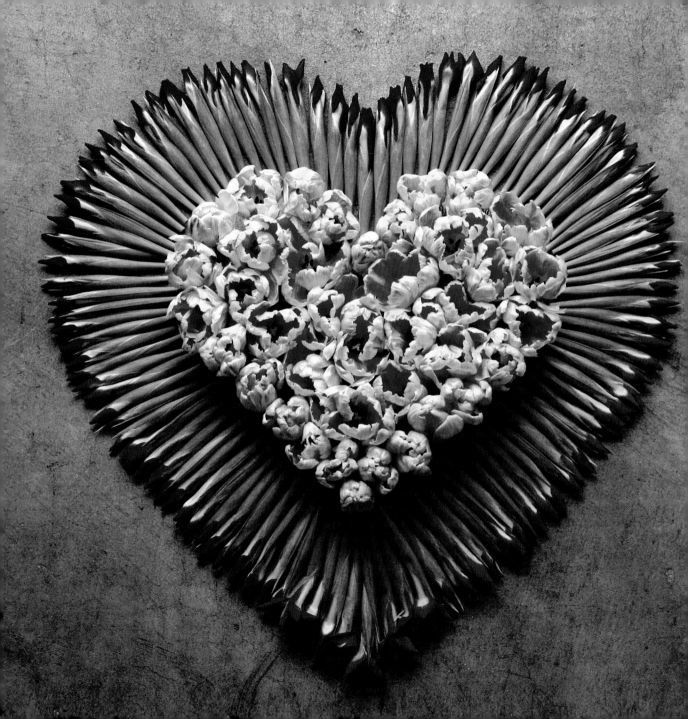

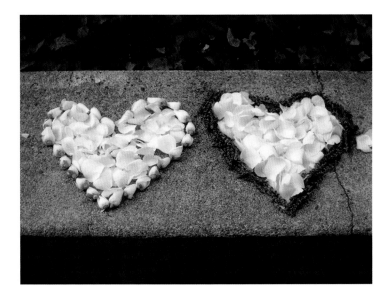

No Monday will there ever be,
from now until eternity,
that you don't have
a heart from me.

GRATITUDE

TO THE RODRIGUEZ FAMILY: JUANITA, GUADALUPE, MOMS, GLORIA, MARY, VAN, MAX, RUBY, MICHAEL, ELENA, VICKI, BLUE, LUCKIE, JOHN, LAUREL, ALLIE JEANE, MACKENZIE, JOE, MICHELLE, HALEY, GIGI, IVAN, ANDY, VANESSA, NICHOLAS, JONATHAN, DALTON, PAMELA, FRANCESCA; MADALENE'S FRIENDS: SIGGY, ELIZABETH, DL, CRIS, SUZANNE, OLIVIA, BETTE, MESSINA, CHRIS, ISOBELLEA, MAISIE, FRED, CUDDLES, EVALANI, TOMOKO, THERESA, TERRI, PAULA, JOHN, DIANE, KYLIE, SANDY; MY MOTHER AND FATHER, PEGGY AND DANY, *for living and loving;* MY BROTHER, MARK; MY NEPHEW, ANDREW; MY SISTER, ALEX; MY NIECE, SKYLAR; MY STEPMOTHER, MARLIES; MY UNCLE TOM, AUNT JUDY, COUSINS GARY AND GAIL, GERMAINE, EDDY, AND MY BEAUTIFUL HODEL FAMILY IN SWITZERLAND; DR. ARZU ASHAN *for her exceptional care and for telling us all the truth and holding us as we absorbed it;* CHELSEA, ANN, AND MONA—*Madalene's nurses and earth angels;* DOTTY *for making Madalene a pretty purple hat by hand;* MAURA AND FATHER MICHAEL, *for being by Madalene's side when she needed you most;* SINDE_EL DAWSON *for your beautiful service;* SUSAN SCHINDLER, DEBORAH GUERRERO, AND TALA RUSSELL *for teaching me the meaning of friendship;* DIANA AND GABBY *for being my family;* EMILY *for taking such good care of Ann;* LISA FERRETTI *for shining so bright through my darkness;* GIA GIASULLO *for being my soul-mate sister;* GITA AND RAMESH *for your love all along;* JOELLE, ELLEN, AND LILI *for being my second family;* JANIS MITCHELL *for your help through the hard times;* PORTLAND BURCHFIELD *for believing in me and being my camera angel;* KELLY *for being there in the waiting room and always;* LAUREL AND AARIN BURCH *for their oceans of inspiration;* BETTY *for being my best Betty of all;* RICHELLE DONIGAN *for your gentle hands and beautiful heart;* CHRIS TOMASINO *for having the vision from the start;* ELINOR *for bringing me to Meg who brought me to Chris. Very special thanks to* ANN STRATTON, *my editor, for holding my hand, and to* LESLIE STOKER *and everyone else at Stewart, Tabori & Chang for bringing this dream to life.* JASON SACHER, LISA BACH, AND DEBRA LANDE AT CHRONICLE *for their vision and amazing work;* thank you TACY *for making the connection.* PIN AT FLOWERS BY MYRNA; MELANIE, ASIF, AND PAUL AT MONTCLAIR ONE-HOUR PHOTO; ELSIE AND ANTONIA AT GREENWORKS FLOWERS; URBANO AND THE CREW AT URBAN FLOWERS; ED, YVONNE, AND JESSICA AT JAVA *for fueling my body and heart;* MAURA MURRAY AND ANN GRANT *for believing early on;* SOPHIA COLLIER *for helping with the contract;* MARGO AND PEGGY AT THE WOMEN'S CANCER RESOURCE CENTER *for their unbelievable dedication;* KYLE AND DAVE AT ARMY STREET MINI STORAGE; THE SUNDAY CREW AT LIME *for your endless critique;* CLAUS MIKKELSEN, *whose humanity touched me in ways he never knew;* SUZY SOMMERS, *my computer angel;* CLAUDE DELVENTHAL, DEBRA PULTZ, BRENDA MARTIN-ENO, AND KATE SOUZA *for their courage and grace;* MY TRIBE WHO RECEIVES THESE HEARTS EVERY WEEK *for your emails of encouragement;* ALL THE FRIENDS *who came and made the human heart;* THE STAFF AT 4-NE ALTA BATES *for their amazing care; and most of all,* ADELAIDE GREEN *for carrying me when my mother could not and for carrying my mother when I could not.*

MADALENE LOUISE RODRIGUEZ

..

MADALENE WAS BORN *in Denver, Colorado, to Juanita and Guadalupe Rodriguez and was the cherished sister of Mary, Michael, Elena, John, Joe, Ivan, and Andy. Madalene went to Cure d'Ars Catholic School for her early schooling, then went on to study Library Arts at the University of Colorado and two years in New York State. Madalene's love for libraries began at a very early age and became the path that would be her lifelong passion and profession. She worked at the University of California Berkeley's Fong Optometry and Health Sciences Library until the time of her death. A lover of art and music, Madalene was a very gifted, creative artist. Her passion for glass and colors—reflected in her collection of antique, translucent marbles—led her to study and master the art of fused glass. Madalene valued family and friendship above all. She was warm, loving, gentle, generous and kind, and had a clever sense of humor. She loved children and took great pride in her nieces, nephews, and the children of those close to her. Her children were her beloved dogs, Blue and Luckie, who she walked daily in the beautiful Oakland Hills. Her home, which she shared with her brother Ivan, was always filled with the delicious aromas of fresh home-cooked meals for friends and family, the hint of sweet incense, and the ever-present sound of her favorite artists, Rickie Lee Jones and Laura Nyro.*

..

Published in 2009 by Stewart, Tabori & Chang
An imprint of ABRAMS

Text and photographs copyright © 2009 Page Hodel

Library of Congress Cataloging-in-Publication Data:
Hodel, Page.
Monday hearts for Madalene / Page Hodel.
p. cm.
ISBN 978-1-58479-778-4 (alk. paper)
1. Hodel, Page. 2. Heart in art. 3. Rodriguez, Madalene
Louise--Miscellanea. I. Title.
N6537.H5635A4 2009
745.5--dc22
2009010629

Editor: Ann Stratton
Designer: Gia Giasullo, Studio eg
Production Manager: Tina Cameron

Stewart, Tabori & Chang books are available at special discounts when purchased in quantity for premiums
and promotions as well as fundraising or educational use. Special editions can also be created to specification.
For details, contact specialmarkets@hnabooks.com or the address below.

Printed and bound in China
10 9 8 7 6 5 4 3 2 1

THE ART OF BOOKS SINCE 1949

115 West 18th Street
New York, NY 10011
www.abramsbooks.com